A–Z

OF

BEXHILL-ON-SEA

PLACES - PEOPLE - HISTORY

Andy Bull

AMBERLEY

Bexhill Museum is a wonderful resource for the historian, or anyone with an interest in Bexhill-on-Sea, and this book is dedicated to its curator, Julian Porter, its staff and volunteers. Also to the staff of the Bexhill Observer, a vibrant chronicle of town life.

First published 2022

Amberley Publishing
The Hill, Stroud, Gloucestershire, GL5 4EP
www.amberley-books.com

Copyright © Andy Bull, 2022

The right of Andy Bull to be identified as the
Author of this work has been asserted in
accordance with the Copyrights, Designs and
Patents Act 1988.

ISBN 978 1 3981 1073 1 (print)
ISBN 978 1 3981 1074 8 (ebook)

British Library Cataloguing in Publication Data.
A catalogue record for this book is available
from the British Library.

Typesetting by SJmagic DESiGN SERVICES,
India. Printed in Great Britain.

Contents

Introduction

Bexhill has always been a pioneering town: the birthplace of British motor racing, the first resort to allow mixed bathing and introduce bathing huts, the town where colour television and a forerunner of the mobile phone were invented, and the venue for Bob Marley's first UK gig.

It may have one of the highest percentages of retired people in the country, but this fascinating town does not deserve its reputation as God's waiting room. Or Spike Milligan's tongue-in-cheek comment that Bexhill is 'the only cemetery above ground'.

Spike actually had great affection for the place where he did his military training during the Second World War. He immortalised it in a *Goon Show* sketch entitled 'The Phantom Batter Pudding Flinger of Bexhill', and in his autobiography, *Adolf Hitler: My Part in His Downfall*.

The town is also celebrated by native Eddie Izzard, who put a replica of the coach from *The Italian Job* on the roof of the town's art gallery, and donated his family's train set to the museum.

A wonderful array of fascinating characters, and a fair few true eccentrics, have called Bexhill home, and I tell their stories here. They include the inventor of the

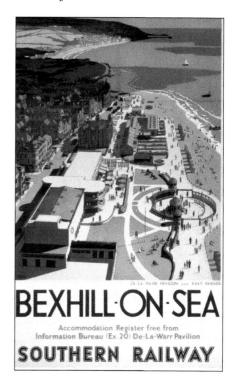

A Southern Railway poster advertising the delights of Bexhill-on-Sea.

death ray that never was, the king of the witches who put a curse on the Bexhill Light Opera Society, and the cobbler with psychic powers.

There is also the story of the Bexhill-built racing car that Elvis drove in the movie *Viva Las Vegas*, and the finishing school for the daughters of prominent Nazis.

All in all, Bexhill is a place of great character and endless fascination, a haven from the modern world that I have returned to time and again over thirty years.

A. B. C. Murders, The

Bexhill features in *The A. B. C. Murders* by Agatha Christie, and inspired two further works. The author got to know the town after enrolling her daughter, Rosalind, at Caledonia School for Girls at Cooden Beach in 1928.

In the book, a series of murders are committed in towns, and on victims, whose names begin with letters of the alphabet, Bexhill being the B. In each crime, the A. B. C. Rail Guide timetable features.

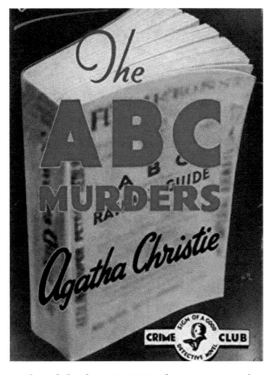
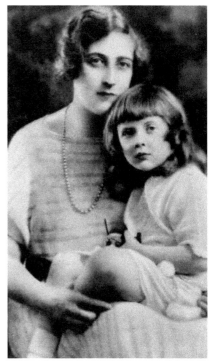

Above left: The A. B. C. Murders was inspired partly by visits to Bexhill.

Above right: Agatha Christie with her daughter Rosalind, a Bexhill schoolgirl.

Christie's hero, Hercule Poirot, announces:

> The body of a young girl has been found on the beach at Bexhill. She has been identified as Elizabeth Barnard, a waitress in one of the cafes, who lived with her parents in a little recently built bungalow ... An *A.B.C.* open at the trains to Bexhill was found actually under the body.

The story was filmed for television in Bexhill in 1991, with David Suchet as Poirot, at locations including the seafront De La Warr Pavilion and at Galley Hill, on the coast at the eastern end of town.

The year 1928 was a difficult time for both Agatha and Rosalind. Two years earlier, Christie's husband Archie had asked for a divorce, and later refused to spend Christmas with his family. Rosalind, who was very close to her father, was bereft, and the event seems to have triggered a breakdown for Agatha.

On 3 December 1926 she disappeared from their home in Sunningdale, Berkshire. Her car was found abandoned above a chalk quarry with her belongings inside. A nationwide hunt for the missing author was launched, and she was found ten days later at a hotel in Harrogate, where she was staying under Archie's mistress's name.

Public interest in the case was so great that mother and daughter fled the country in January 1927, sailing to the Canary Islands where Agatha was to rest and recover from her trauma. She never spoke about the incident with her daughter, who remained devoted to her estranged father. In Christie's *An Autobiography*, she wrote only: 'So, after illness, came sorrow, despair and heartbreak. There is no need to dwell on it.'

The divorce became absolute in October 1928, just when Rosalind was enrolling at the Caledonia school. Agatha immediately left the country, taking the Orient Express to Istanbul and travelling on to Baghdad, where she took part in archaeological digs.

This was a terribly lonely time for Rosalind. From spending months together with her mother she was now alone and friendless, at a new school in a strange town.

In Baghdad, Agatha met Leonard Woolley, who became her second husband in 1930. That year, Agatha drew on her difficult relationship with her daughter in a play, *A Daughter's a Daughter*, in which, Rosalind believed, the central character was based on her. In it, according to AgathaChristie.com:

> The love between a mother and daughter turns to jealousy and bitterness ... Ann Prentice falls in love with Richard Cauldfield and hopes for new happiness. Her only child, Sarah, cannot contemplate the idea of her mother marrying again ... Resentment and jealousy corrode their relationship as each seeks relief in different directions. Are mother and daughter destined to be enemies for life or will their underlying love for each other finally win through?

Rosalind's son, Mathew Prichard, said: 'It's hard for me to avoid the fact that the character of the daughter reminds me a lot of my mother. It is eerie.'

The play was only performed after Rosalind's death in 2004 but had been adapted by Christie into a novel, published under the pseudonym Mary Westmacott, in 1952.

When a film about Christie's disappearance, *Agatha*, was made in 1979, starring Dustin Hoffman and Vanessa Redgrave, Rosalind unsuccessfully sought an injunction to prevent its distribution.

Caledonia House, in Clavering Walk, later became Portsdown Lodge, but that school closed in 1964 and the building was later demolished. Christie drew on the staff, pupils and routine at the Caledonia – and at Benenden, Rosalind's subsequent school – in another crime story, *Cat Among the Pigeons*.

Amsden, Walter

Among the many treasures in Bexhill Museum is a large collection of ancient Egyptian artefacts, some of them donated by Dr Walter Amsden. Amsden accompanied the great Egyptologist Sir William Flinders Petrie as medical officer on digs in 1913.

With his medical background, Amsden made an invaluable contribution to the examination and cataloguing of human remains unearthed at Harageh, a village 60 miles south of Cairo, where cemeteries spanning 1850 to 1750 BC were discovered.

Amsden worked with Flinders Petrie's colleague Reginald Engelbach in the examination and cataloguing of inscribed coffins, boxes and jars used to hold human remains during the mummification process and preserve them for the afterlife, and many statues that had adorned graves.

Dr Amsden's Bexhill connection was forged when he was stationed at Cooden Camp, on land north of Clavering Walk, during the First World War. He became friends with Bexhill Museum's co-founder Kate Marsden (see separate entry). The museum supported the excavations, which were sponsored by the British School of Archaeology in Egypt, and gained many of its 300 exhibits through that connection. However, Amsden's personal contribution of pottery vessels, flints, beads and a mummified crocodile was in addition to that.

Flinders Petrie developed the system of dating layers excavated through the pottery and ceramics found in them, and pioneered the systematic preservation of artefacts.

Amsterdam

In 1748 a Dutch East Indiaman, the *Amsterdam*, was wrecked off Bulverhythe with a rich cargo, including thirty chests filled with silver bullion, and other valuables which Bexhill townspeople periodically sought to recover.

At the time of the wreck, one chest of silver was looted before the rest was recovered by Revenue officers. In 1810, soldiers from the Bexhill-based King's German Legion made a further, unsuccessful attempt to plunder the riches. In 1827, forty Bexhill

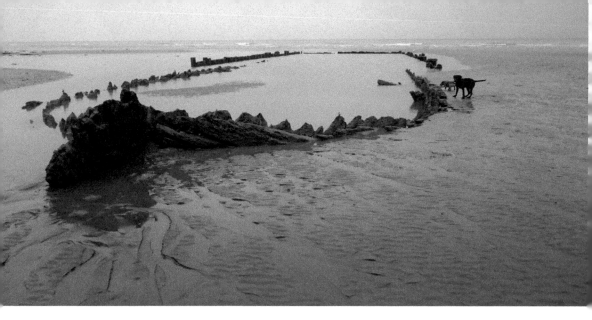

Above: The wreck of the *Amsterdam*. (Marshall Pearce under Creative Commons)

Left: A replica of the *Amsterdam* outside Holland's National Maritime Museum. (S. Sepp under Creative Commons)

townspeople managed to recover a haul of glasses, cutlery and tobacco pipes before Revenue officers drove them away.

The *Amsterdam* had been on its maiden voyage, sailing to Java via the Cape, when it encountered a ferocious storm in the English Channel. An epidemic of yellow fever broke out among the crew, which mutinied. When the ship's rudder was smashed by the pounding waves in Pevensey Bay, it was driven towards the shore between Bexhill and Hastings, finally becoming grounded. It quickly sank 25 feet into the soft mud of the seabed.

For well over a century the ship was hidden, but in 1969 a very low spring tide exposed its hull. Two-thirds of the ship was intact, preserved in the mud, but was once again vulnerable to treasure hunters. According to Carly Hilts, writing in *Current Archeology*:

Workmen building a nearby sewer outlet used their mechanical diggers to tear open the wreck. Artefacts ranging from bronze cannon and rigging to tobacco pipes and tableware spilled forth – much to the horror of local archaeologists, who had no legal powers to prevent the damage as, at that time, historic wrecks were not accorded the same protection as heritage sites on land.

However, archaeologist Peter Marsden was able to survey the site over the following year. A dam was erected around the wreck and the sand pumped out, allowing the ship to be examined. It was then covered over again to preserve it. In 1973, the Protection of Wrecks Act brought legal protection, and the ship is owned by the Dutch government. Finds from the *Amsterdam* are housed in the Shipwreck Museum in Hastings, and at Amsterdam's National Maritime Museum, outside which floats a life-size replica of the ship.

Ever since its discovery, the ship has intrigued townspeople and visitors, and the emergence of the ribs of its hull and lower timbers at low spring tides draws many to walk out to it, attracted by a remarkable piece of history.

Armada

During Elizabeth I's reign, defences were built up against the threat of invasion from Spain around Cooden Stream, and fire beacons set up on Cooden Down to warn of the approach of the Spanish Armada.

Austen, Jane

The opening of Jane Austen's unfinished 1817 novel *Sanditon* describes the area around Bexhill, which makes it tempting to think that the town is the model for the resort in the book.

Austen writes:

> A gentleman and lady travelling from Tunbridge towards that part of the Sussex coast which lies between Hastings and Eastbourne, being induced by business to quit the high road, and attempt a very rough lane, were overturned in toiling up its long ascent half rock half sand.

The couple are Mr and Mrs Parker who, together with a partner, have ambitious plans to transform Sanditon from a small fishing village into a fashionable resort. Bexhill was indeed a small village and, in many ways, the process of its transformation fits the description in the book.

Above left and above right: Jane Austen and her novel about a seaside resort, *Sanditon*.

Austen describes Sanditon:

> Everybody has heard of Sanditon. The favourite for a young and rising bathing-place, certainly the favourite spot of all that are to be found along the coast of Sussex – the most favoured by nature, and promising to be the most chosen by man.

Other Sussex resorts have been suggested as the model, including Worthing. However, when Mr Parker is defending Sanditon he compares it to those resorts in a way that would seem to rule them out. To the charge that such places are 'Bad things for a country – sure to raise the price of provisions and make the poor good for nothing' he counters:

> It may apply to your large, overgrown places like Brighton or Worthing or Eastbourne but not to a small village like Sanditon, precluded by its size from experiencing any of the evils of civilization.

Bexhill is certainly a far smaller resort than any of the others on the Sussex coast. Mr Parker says Sanditon is 'a mile nearer London than Eastbourne' and Bexhill is indeed a couple of miles closer.

However, there is one big hole in Bexhill's claim, which is that it did not become a resort until the 1880s, a good sixty years after Austen wrote *Sanditon*. Could Jane Austen have foreseen its development?

Baird, John Logie

The inventor of television spent the last eighteen months of his life in Bexhill while developing the world's first cathode ray tube for colour TV. He moved with his wife Margaret and children Malcolm and Diana to No. 1 Station Road in January 1945, following the bombing of his house in Sydenham.

Baird's health was poor, and it was hoped the Sussex sea air would help his heart condition. It had worked previously, in 1923, when he moved to Hastings after a previous collapse in his health, and it was there that he transmitted the first television pictures.

The war years also involved financial struggle for the Baird family. The BBC ceased television transmission suddenly at the outbreak of war in September 1939, for fear that the VHF transmissions would act as a beacon to enemy aircraft homing in on

John Logie Baird. (George Grantham Bain collection at the Library of Congress)

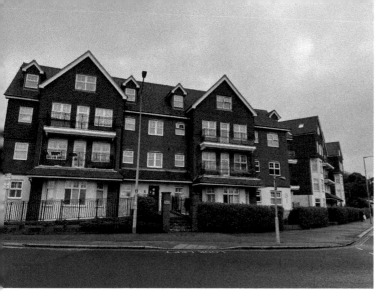

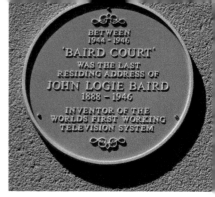

Left and above: The site of Baird's former home in Station Road, marked with a blue plaque.

London. As a result, Baird's television manufacturing company went out of business, and he had to carry on his experiments at his own expense.

In 1944, with the end of the war in sight, Baird founded a new company, later commuting from Bexhill to London, where he continued his research, and prepared for the resumption of TV broadcasts. However, his health was still poor, and he suffered a stroke in early 1946 which confined him to bed. He died that June, at the age of fifty-seven, just a week after BBC television returned to the airwaves.

The great advances Baird had made in colour television would not see the light of day for decades after his death. In 1943 he had persuaded the Hankey Committee, appointed to oversee the resumption of TV, to adopt his 1,000-line Telechrome electronic colour system as the new post-war broadcast standard. The picture quality would have been comparable to modern HDTV. However, the plan was not adopted. Monochrome TV, with just 405 lines, remained standard, with 625-line colour only becoming available in 1964.

The Baird family home was demolished in 2007, to be replaced by flats.

Bathing

Bexhill was at the forefront of the fashion for sea bathing, and in 1901 was the first English resort to allow mixed bathing, an innovation that brought fame and notoriety in equal measure. Some feared an outbreak of immorality but, in fact, the measure simply meant families could swim together for the first time.

In 1911 the *Bexhill Chronicle* reproduced a report from the *London Evening Standard*, applauding two more innovations: the provision of canvas changing tents, and static beach huts. It read: 'Just as Bexhill was a pioneer of mixed bathing, so it has taken a lead in another way, namely, in the provision of conveniences for bathers.' The resort had abandoned the cumbersome and outmoded bathing

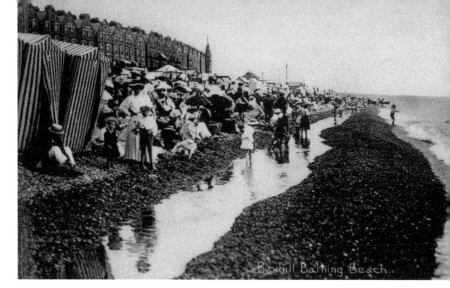

Bexhill
pioneered
mixed bathing,
and the use of
beach huts.

East Parade and Galley Hill, Bexhill-on-Sea.

machines, huts-on-wheels that had to be towed into the sea by horses. Now, the report continued:

Where many of them were formerly stationed are now up-to-date canvas tents and huts. The former give the Bexhill beach in the summer time a likeness to some Continental beach, for they are gaily coloured and set promiscuously along the shore ... but the [beach] huts constructed last year below the Central Parade are the most popular of all Bexhill's bathing provisions ... Each hut is lighted by electricity, and has a separate department in which the bather may obtain a warm or cold shower.

In 2001 a centenary celebration of the advent of mixed bathing was held, with swimmers taking to the sea in historic costumes.

Battle of Hastings

Although the Battle of Hastings took place 7 miles to the north of Bexhill, at Senlac Hill, it would seem that the Norman invasion had a devastating effect on the town.

The Domesday survey shows that, while Bexhill was worth £20 before the invasion – at which William the Conqueror's troops landed at Pevensey, to the west – it was worth nothing after it, and was still worth less than the pre-invasion value when the Domesday audit was conducted in 1086, being valued at £18/10s.

Beeching, James

James Beeching (1788–1858) came from a family of Bexhill smugglers, and married into the Thwaites family of Hastings shipbuilders. James learned the craft and opened his own yards, first in Hastings, then in Flushing, Holland, and finally in Great Yarmouth.

In 1850 he entered a competition to design a lifeboat. His winning design for the Self-Righting Pulling and Sailing Lifeboat was taken up by the Royal National Lifeboat Institute, and hundreds were built for the RNLI's fleet from 1852 to 1890.

Belle Hill Barracks

George III was also the Elector of Hanover, and after Napoleon invaded Hanover in 1803, over 5,000 troops loyal to George fled to England, and Bexhill, where they became the King's German Legion.

An enormous barracks was built for them at Belle Hill, stretching west from the Old Town and north along Holliers Hill towards Sidley. Traders keen to exploit this new market opened shops and inns close to the barracks, including the Black Horse at No. 10 Belle Hill (later the Queen's Head and since closed). Soldiers may have created a bowling green at the New Inn, Sidley.

The troops vastly outnumbered Bexhill's then population of 1,000, and stayed until 1814.

They became part of the British Army, but as a distinct German component, with George's son Adolphus Frederick, Duke of Cambridge, as their colonel-in-chief. The King's German Legion played a vital role in the Napoleonic Wars of 1804–15, but was disbanded after victory at the Battle of Waterloo.

The soldiers' families remained in Bexhill while they were away, and a German school was established. The Barrack Road Memorial Gardens, once a military cemetery, is a rare reminder of their presence.

Above and right: Barrack Hill Memorial Gardens, on the site of a soldiers' graveyard. (Dr-Mx under Creative Commons)

Blues Unlimited

The first magazine in the world dedicated exclusively to Blues music was founded in Bexhill in 1963. *Blues Unlimited* became hugely popular with the musicians and fans who were then embracing American Blues and adapting it into British Rhythm and

Blues. The Rolling Stones, Eric Clapton, Paul Jones and Manfred Mann were among its readers.

The magazine was founded by Simon Napier and Mike Leadbitter, who had met as pupils at Bexhill Grammar School, and run from Simon's parents' house at No. 38a Sackville Road. The previous year they had created the Blues Appreciation Society, and *Blues Unlimited* was launched as its journal.

Blues Unlimited was, however, a rough-and-ready publication to begin with: typed, mimeographed and stapled together like a forerunner to the fanzines that flourished a decade later. Only 180 copies of the first monthly edition were produced, but it quickly became professionally produced, commercially successful, and highly influential.

It brought a knowledge of Blues performers such as B. B. King, Muddy Waters, Elmore James, and John Lee Hooker – plus awareness of the history of the genre – to a wide audience of young whites.

In 1970 Simon and Mike formed a record label, Flyright Records, reissuing often rare and obscure Blues and R&B classics, plus new recordings by British jazz and rock bands. They had a record store in Wickham Avenue, and later in Sackville Road, until the mid-1980s.

The pair are recognised as being key influencers, whose advocacy spearheaded Blues' crossover into the mainstream.

Famous Blues performers including Juke Boy Bonner came from America to Bexhill to meet the team behind the magazine. Bonner, who recorded for their Flyright label, came for three weeks in 1969. He wrote a song, 'B U Blues', released on his *Things Ain't Right* album, in which he sang:

> I left London on a Monday morning
> Going down to Bexhill-on-Sea ...
> Thought the air would do something for poor me
> I was walking round Bexhill
> When I thought about my woman back home
> You know Bexhill a lonely place if you've ever been around there.

After Leadbitter's sudden death from meningitis in 1974, Napier bowed out and others took over. The magazine moved to Blackheath, south London, and ceased publication in 1987. Early copies are now collectors' items. Simon died in 1990.

Brisley, Ethel, Joyce, Nina

The three daughters of George Brisley, who ran the Red Cross Pharmacy in London Road, became children's authors and illustrators. Joyce (1896–1978) wrote the *Milly-Molly-Mandy* stories, comforting tales about a little girl in a pink- and white-striped dress who lives in an idyllic cottage, as she grows up from the ages of four to eight.

Joyce, Ethel and Nina first turned to illustration out of necessity. Very unusually for the time, their parents divorced, in 1912, when they were in their teens, and their father turned them and their mother out of the house.

The three sisters, who all attended Hastings Art College, illustrated postcards, Christmas cards and children's annuals to support the family. Nina illustrated Elinor Brent-Dyer's *Chalet School* series. Joyce also turned her hand to advertisements for Cherry Blossom shoe polish and Mansion floor polish. Joyce once said that those illustrations were 'bread and butter for a good many years'.

The idea of *Milly-Molly-Mandy* came about as she doodled a family group on the back of an envelope, trying to come up with 'a speciality' that would 'earn some money or other'. She wrote a story to go with the doodle and sent it to the *Christian Science Monitor*, which published it in 1925. More stories followed, and later a series of books. Lucy Mangan, writing in *The Guardian*, said:

> Every *Milly-Molly-Mandy* story is a miniature masterpiece, as clear, warm and precise as the illustrations by the author that accompanied them. They are crafted by a mind that understood the importance and the comfort of detail to young readers without ever letting it overwhelm the story. Maybe the creation of this calm, neat, ordered world was a comfort to the author too, coming as she did from a broken home.

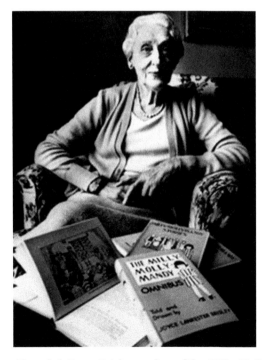

" *Hide and Seek* "
Now don't you give me away

Above left: Joyce Brisley, author of the *Milly-Molly-Mandy* books.

Above right: One of many postcards designed by Nina Brisley.

C

Cinemas

The first moving pictures to be screened in Bexhill were those of Gladstone's funeral, shown at the Kursaal (see separate entry) in 1898. The first purpose-built cinema was The Bijou, in Buckhurst Place, opened in 1910. It became the St George's Cinema Theatre in 1914, but closed in 1954, and was later demolished.

The Cinema de Luxe opened in Western Road in 1913, and the owners developed the site next door as the Picture Playhouse in 1921, closing the de Luxe.

The Playhouse was divided up in 1974, the circle becoming the Curzon, the stalls housing a bingo hall and, later, an antique market. It was reborn as the Redstack Playhouse, a cinema and theatre, in 2005 but closed three years later. It is now the Picture Playhouse once again, but only in name – it is actually a branch of the Wetherspoons pub chain.

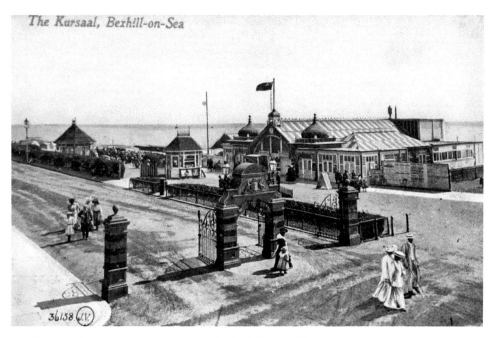

The first moving pictures were screened in Bexhill at the Kursaal.

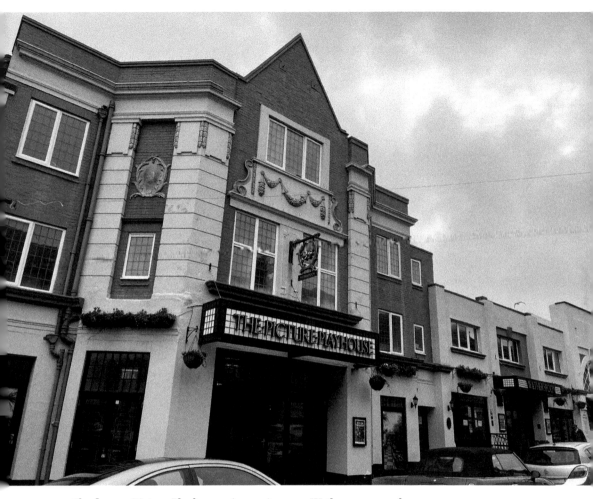

The former Picture Playhouse cinema is now a Wetherspoons pub.

The Ritz, the town's largest cinema, opened in Buckhurst Road in 1937 on the site of a former roller-skating rink. It closed in 1961 and the town's telephone exchange was built on the site.

Coal

The construction of Martello towers along the seafront in 1804 led to the discovery of what was thought to be coal, a desperately needed commodity at the time. In fact what had been unearthed was worthless black lignite, or fossilised wood.

Surveys were conducted across the Sackville estates and, on the strength of wildly inaccurate reports that 'a vein of exceedingly fine coal' had been discovered, a mining company was formed, pits dug and massive sums invested.

Mining conditions were challenging, pits constantly flooded, and overworked steam engines wore out. After six years it was finally accepted that no coal would be found, and several local fortunes were lost.

Cradock, Fanny

Phyllis Nan Pechey, better known as Fanny Cradock, was Britain's first TV celebrity chef, and a formidable character, with conflicting strengths and failings. She married four times – twice bigamously – and was a bully who abandoned her children. Fanny was also a female colossus who championed women's rights.

She and husband Johnnie retired to Bexhill, where they lived at No. 95 Cooden Drive until his death in 1987.

Fanny (1909–94) presented twenty-four television series between 1955 and 1975, dressed in evening gown, drop earrings and pearls, alongside her often seemingly squiffy stooge, Johnnie. She was outspoken, berating Margaret Thatcher for wearing 'cheap shoes and clothes', and hugely influential.

Below and opposite: No. 95 Cooden Drive was the retirement home of Fanny Cradock, the first celebrity chef. (Allan Warren under Creative Commons)

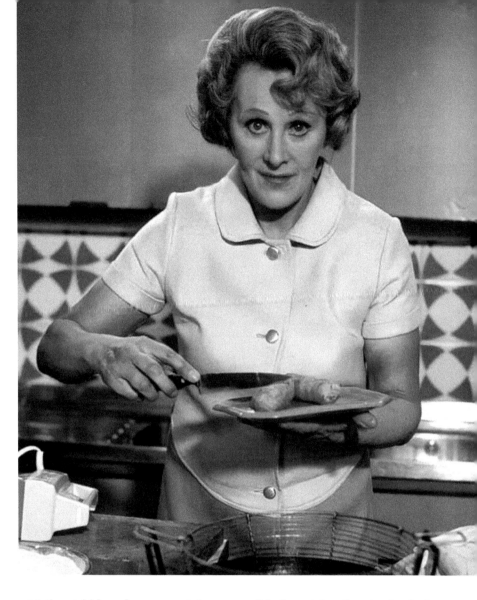

The Queen Mother told her she was mainly responsible for raising the standard of British food following the nadir of the post-war years of rationing, Esther Rantzen that she created the cult of the celebrity chef, and the restaurant critic Fay Maschler that she was 'the Madonna of her day'.

Fanny was an easily parodied character – the comedian Benny Hill imitated her in a series of TV comedy sketches – but also gained the public's affection. In later years the couple became chat-show regulars, and appeared on programmes such as *The Generation Game* and *Blankety Blank*.

After Johnnie's death, Fanny endured a sad decline. Clive Ellis writes, in *Fabulous Fanny Cradock*, that she was found living in squalor, 'dirty, disorientated and desperate', by a family friend, Phil Bradford. He gained power of attorney and ensured she was moved to Ersham House nursing home in Hailsham, where she was cared for until her death.

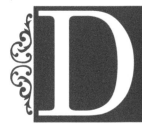

Dad's Army

The classic BBC comedy *Dad's Army* is set in the fictional town of Walmington-on-Sea, but there are one or two tantalising clues within episodes that suggest writers Jimmy Perry and David Croft may have had Bexhill in mind, at least partially, when they created the show.

In a 1969 episode entitled 'The Day the Balloon Went Up' a military map shows Walmington between Eastbourne and Hastings. Eastbourne is frequently referred to as the nearest big town, and is said to be on the same railway line as Walmington. Captain Mainwaring was educated at its grammar school.

In their book *Dad's Army*, Perry and Croft describe Walmington in terms that could also be ascribed to Bexhill:

> It is only a little place. People with not too much money can retire there to spend their declining years in small houses and bungalows. In happier times, a string of neat comfortable Georgian guest houses could accommodate well-mannered families during the summer months. Mother and father could listen to the band while the children played on the fine clean sand, or the whole family could watch the Pierrots.

However, other clues point to a place in Kent, perhaps Birchington-on-Sea, Walmer or Deal. The platoon's cap badges show the county symbol of Kent. Also, while Walmington has a pier, Bexhill does not.

Dawson, Charles

The amateur antiquarian Charles Dawson claimed in 1894 to have discovered an ancient boat near Bexhill, and submitted sketches of the find to archaeological journals. The wooden boat was elliptical, with a broad, flat bottom.

However, as Dawson was behind the Piltdown Man hoax, in which bones that appeared to show fossil evidence of the missing link between apes and humans were found to be forgeries, there must be doubts over the story.

Death Ray Matthews

In 1923, Harry Grindell Matthews became world famous when he claimed to have invented a ray that could shoot down aeroplanes and ignite gunpowder. He became known as Death Ray Matthews, and was a darling of the press.

Time magazine declared:

> In the future ... the death ray will sweep whole armies into oblivion, whole cities into bleak, smouldering ruins, explode bombs in mid-air, blow up ammunition dumps from great distances; in a word, make existence for those who do not possess its mysterious secret impossible, and, so he says, end war.

The trouble was, Grindell Matthews (1880–1941) had not actually demonstrated that his ray could do anything more than stop a motorbike engine, and there were suspicions that even this achievement might be down to trickery.

All of which makes Grindell Matthews sound like a mad inventor, or just a fraud. However, over his life he would show himself to be a remarkable visionary and pioneer with a string of inventions to his name, some of which actually worked.

Grindell Matthews came to Bexhill in 1905 as consulting engineer for Earl De La Warr, who was renovating the Manor House (see separate entry). There he oversaw the installation of electricity and a telephone system. For seven years he worked on a range of other projects from a laboratory provided by the Earl, and a hut on the roof of the Kursaal. Among them were wireless telephony, and wireless-guided torpedoes.

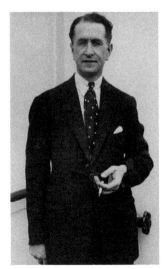 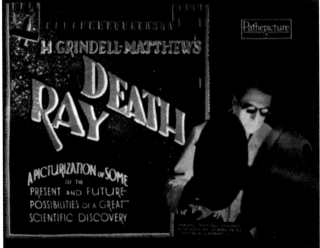

Above left and above right: Harry Grindell Matthews, and a Pathe News film about his supposed Death Ray.

From the Kursaal he worked on sending messages by Aerophone, which functioned rather as a modern mobile phone does, and claimed to have communicated by voice call with a boat 3 miles out to sea. He said he would demonstrate his wireless torpedo to the Royal Navy by guiding a dummy one from the Kursaal to the Royal Sovereign Light, a distance of 8 miles. In fact, the demonstration never took place.

The War Office and the Admiralty, forerunners of the Ministry of Defence, later became interested in the Aerophone, and a demonstration was arranged. Matthews insisted no experts be present. However, write David Clark and Andy Roberts, in *Grindell 'Death Ray' Matthews*:

> Before it was completed Matthews' assistant discovered four of the invited observers had taken advantage of his absence from the room to dismantle the apparatus, taking notes and sketches. In a rage, Matthews cancelled the demonstration immediately and sent everyone away.

The press championed Matthews against what was portrayed as official duplicity and intransigence. The War Office responded, denied tampering and claimed the experiment had failed.

In 1914 Grindell Matthews had more luck. The government was keen to identify inventions that could help win the war with Germany. A £25,000 prize was offered for a device that could disable Zeppelin airships remotely, or control unmanned boats.

Matthews claimed he could provide the latter, and successfully demonstrated it to officials. He won the prize, but the device later proved to be impractical, and was never pursued. Clark and Roberts ask:

> Was this ignorance and jealousy on behalf of the War Office or the first hints that Matthews wasn't quite as genuine as he appeared? ... Was he a charismatic mixture of visionary and charlatan, or an ignored and embittered inventor who could have shortened both World Wars?

Other inventions certainly did work. In 1921 Grindell Matthews produced the world's first talking picture, in which dialogue was synchronised with images. It showed the explorer Ernest Shackleton prior to his fatal attempt at circumnavigating the Antarctic.

The British film industry rejected the idea, saying talkies would never catch on. They did, in America, later that decade.

When Grindell Matthews came up with the death ray he took it first not to government, but the press. His electric ray was capable, he said, of causing aircraft to fall from the sky by putting their magnetos, a form of alternator vital to the functioning of the craft, out of action. He demonstrated the device to journalists, stopping a motorcycle engine at 50 feet. This was a modest success, but he made far greater claims:

I am confident that if I have facilities for developing it I can stop aeroplanes in flight – indeed I believe the ray is sufficiently powerful to destroy the air, to explode powder magazines, and destroy anything on which it rests.

The War Office was sceptical but, fearful that a foreign government might take the death ray up, approached the inventor. He was told that if the ray could stop a motorcycle engine under conditions that would satisfy the Air Ministry, he would be given £1,000 to develop it.

Matthews refused, and flew to America, where he was asked to demonstrate the ray at a radio fair in Madison Square Gardens, but again declined to reveal how it worked. On his return to England he claimed the Americans had bought his ray. They had not, and no more was heard of it.

This was not the last to be heard from the inventor, though. On Christmas Eve 1930 he captivated Londoners by projecting the image of an angel onto clouds over Hampstead Heath. The impression was so realistic that some believed it heralded the Second Coming. The invention pre-dated by decades the modern advertising practice of projecting laser images onto buildings and into the sky but, once again, no one was interested in it.

De La Warr Pavilion

This elegant, modernist concert hall and exhibition space is considered one of the finest art deco public buildings in the country, but was opposed by many in the town when it was developed in 1935. They considered it designed for visitors, rather than residents.

Spike Milligan (see separate entry), stationed in Bexhill during the Second World War, wrote of it, tongue in cheek, as: 'a fine modern building with absolutely no architectural merit at all. It was opened just in time to be bombed. The plane that dropped it was said to have been chartered by the Royal Institute of Architects.'

The pavilion was commissioned and paid for by Herbrand, 9th Earl Sackville, as a strikingly modern asset to the town. He announced a design competition in which the brief was very open. It read:

It is the intention of the promoters that the building should be simple in design, and suitable for a holiday resort in the south of England. Character in design can be obtained by the use of large window spaces, terraces and canopies. No restriction as to style of architecture will be imposed but buildings must be simple, light in appearance and attractive ... Heavy stonework is not desirable ... Modern steel framed or ferro-cement construction may be adopted.

The competition was won by the architects Erich Mendelsohn and Serge Chermayeff, their building featuring a 1,500-seat auditorium, a 200-seat restaurant, a reading room, and a lounge. It cost £80,000 (£6 million today).

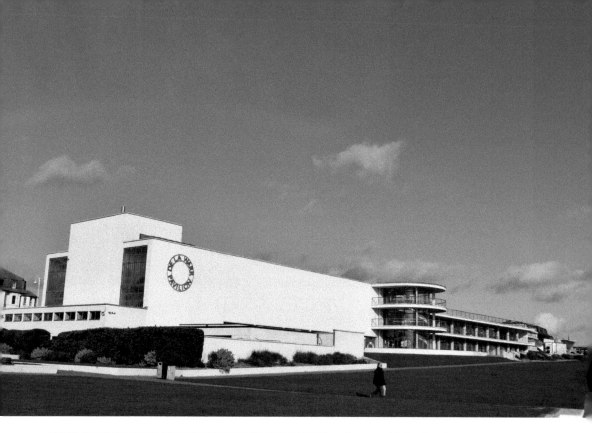

Above and left: The elegant, modernist De La Warr Pavilion.

Mendelsohn (1887–1953) was Jewish and had fled to England from Nazi Germany in 1933. He specialised in department stores and cinemas, designing them in a style variously described as Art Deco, Streamline Moderne and International.

The playwright George Bernard Shaw said, when the pavilion opened: 'Delighted to hear that Bexhill has emerged from barbarism at last, but I shall not give it a clean bill of civilisation until all my plays are performed there once a year at least.'

During the Second World War it was occupied by the military, and suffered minor damage when the adjacent Metropole Hotel was destroyed by German bombers. It was later taken over by Bexhill Corporation, forerunner to Rother District Council.

In the 1970s and 1980s the pavilion entered a period of neglect and decline, and suffered alterations inconsistent with its original design. However, in 1986 it was awarded Grade I listed building status, and a group was formed dedicated to protecting and restoring it. A £6 million Heritage Lottery Fund award in 2002 enabled the building to be restored as a contemporary arts centre, with one of the largest galleries on the south coast.

Dinosaurs

Bexhill offers rich finds for dinosaur hunters. In a world-first, fossilised dinosaur brain tissue – 133 million years old – was discovered on the beach by a local amateur palaeontologist.

The find, by Jamie Hiscocks, belongs to a relative of the Iguanodon, a herbivorous dinosaur that lived during the early Cretaceous period. The mineralised tissue, which

A dinosaur egg sculpture in Egerton Park. (Dr-Mx under Creative Commons)

Evidence of a vast, now submerged Neolithic forest is revealed at low tide.

looked just like a pebble, was discovered in 2004, but it took years for scientists to confirm that the find was one of the most exciting discoveries in palaeontology.

Jamie, together with his brother Jonathan, also discovered the world's oldest spider web – 140 million years old – encased in amber. It was probably trapped there during a forest fire, and was uncovered in 2009.

Prior to such finds, Bexhill had been overlooked as a hunting ground. Jamie told *The Argus*:

> When I first began collecting fossils here twenty years ago, geologists told me that being a coastal site with no fossiliferous cliffs, it wasn't good fossil hunting grounds and that I probably wouldn't find anything interesting. Intuitively, I felt there was much to discover.
>
> My hunch [about the brain tissue] was verified by scientists many years later. I allowed the specimen to be studied by scientists for two years and the fossil travelled the globe. A huge scientific data set was gathered and scientific papers published on the amazing fossilised dinosaur brain.

Trails of dinosaur footprints are often spotted on the beach at low tide, and fossilised dinosaur bones are occasionally unearthed during winter storms. Perfectly preserved prehistoric hazelnuts, plus tree roots, trunks and branches that sometimes wash up are evidence of a vast and now submerged Neolithic forest which once ran along the coast.

Easter Egg Steam Car

Leon Serpollet's Easter Egg Steam Car, the world's then fastest car, achieved 54 mph at the Bexhill Speed Trials of 1902. At the time, steam cars performed competitively with those powered by internal combustion engines. Serpollet won the World Land Speed Record the same year, recording 75 mph over a measured kilometre on the Promenade des Anglais at Nice.

A replica of the car is in Bexhill Museum, and a tubular sculpture inspired by it stands on the seafront opposite the Sackville.

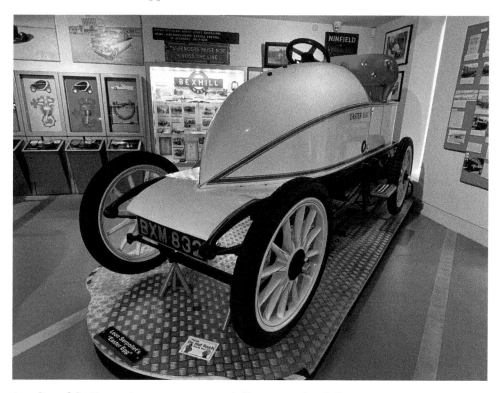

A replica of the Easter Egg steam car in Bexhill Museum. (Bexhill Museum)

Education

Education, specifically providing boarding schools for the children of expats, was almost as big an industry as tourism for the first half of the last century. There were around 300 independent schools in Bexhill before the outbreak of the Second World War, but few reopened following it.

Instead, many who had been to school in the town before spending their working lives in Britain's colonies retired here.

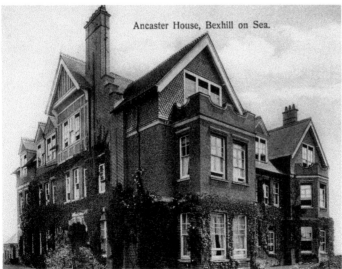

Ancaster House, Bexhill on Sea.

Above and left: Bexhill College was built on the site of Ancaster House school.

Many of the schools were substantial, with imposing buildings and extensive grounds. Revd F. Burrows's Ancaster House, a 'school for young gentlemen', moved here from St Leonards in 1898. It covered almost 4 acres at the junction of Hastings Road and Penland Road (then Upper Dorset Road) and is now the site of Bexhill Sixth Form College. Paul McCartney's children James and Stella both attended Bexhill College.

Bexhill Museum's *The Best Days of Your Life?* charts the history of schools on the site. It became a girls' school in 1906, and in 1917 took over Ebor School, catering for younger pupils at what was named Ancaster Gate. In 1986 it merged with Charters Tower, another girls' school with substantial grounds on Hastings Road, to become Charters/Ancaster. That school closed in 1995 and the buildings were demolished.

However, in 1996, Charters/Ancaster was revived, reopening a co-educational school in Woodsgate Place, Gunter's Lane.

Beehive was another distinguished school with an impeccable pedigree. In 1900 it moved to Bexhill from Windsor, where it had been established to cater for the sisters of boys at Eton College. Intake was wider after the move, occupying three large houses, Nos 1, 3 and 5 Dorset Road. The school was evacuated, along with many others, during the Second World War, but returned to different premises, closing in 1964.

Bexhill School of Domestic Economy, at Colwall Court, Pages Avenue, opened as a finishing school in 1935 but closed in 1958. Among its pupils is Norma Major, wife of the former prime minister John Major. The building subsequently became the Variety Club's Sunshine Home, and is now Phoenix House, a drink and drug counselling and treatment centre.

Harewood Preparatory School, in Collington Avenue, was attended by the playwright David Hare (see separate entry) and the conservative politician Reginald Maudling. It amalgamated with the adjacent Normandale Preparatory School in 1963 and its premises were demolished in the early 1970s.

Among Normandale's pupils were the actor Sir Alec Guinness, and actor-playwright turned political speechwriter Sir Ronald Millar. Millar wrote for three Conservative prime ministers: Edward Heath, Margaret Thatcher and John Major. He coined the phrase 'the lady's not for turning' in a speech delivered by Lady Thatcher in 1980. It is considered to be a defining line, delivered at a critical moment for the embattled prime minister. It underscored her determination not to U-turn over her mission to reduce state intervention in the economy.

Elva

In the 1950s Bexhill boasted its own brand of sports car: the Elva, which looked very like an E-type Jaguar, and was the creation of Frank Nichols, born in the town in 1920. Bexhill Museum has a restored Elva Mark III on display.

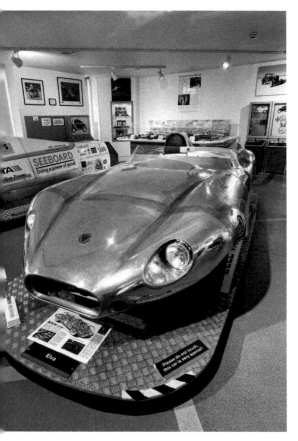

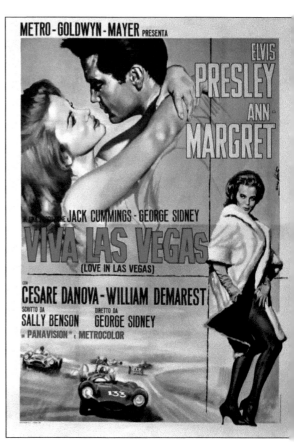

Above left and above right: Elvis Presley drove a Bexhill-made Elva sports car in *Viva Las Vegas*. (Bexhill Museum)

Frank left school at fourteen and, after serving in the army in the Second World War, bought a garage in Westham, 7 miles west of Bexhill. He later moved to bigger premises in London Road, Bexhill.

An interest in motor sport – of which there was a strong tradition in the town (see 'motor racing' entry) – led him to buy and race cars. The realisation that the cars he drove could be improved – and marketed more effectively – led him in 1955 to build a racer of his own. The name Elva is a corruption of the French 'elle va', meaning 'she goes'.

His innovative designs led to great success in the UK and USA during the 1950s and 1960s, and around a thousand track and road cars were produced. Nichols moved to a larger factory in Hastings where, from 1958, he produced the Elva Courier road-going car.

Two Elvas feature in the Elvis Presley movie *Viva Las Vegas* with one, a 1961 Mark VI sports racer, being driven by Elvis himself.

The firm hit cash-flow problems when an American distributor got into financial difficulties, and Elva was forced into voluntary liquidation. Another firm, Trojan, bought

the rights to the Courier in 1961 and took over production. Frank Nichols was able to open a much smaller factory in Rye to continue building track-racing cars. On Boxing Day that year, an Elva Mark VI raced at Brands Hatch, coming second to a Ferrari raced by Graham Hill, who was to become Formula One World Champion a year later.

Nichols also had an interest in boats, and from 1982 developed the Brede class lifeboat for the Royal National Lifeboat Institute. It was adapted from a fishing boat for amateur sea anglers, the Lochin 33, that Frank had designed in the early 1970s. At its introduction, the Brede was the fastest all-weather lifeboat in the RNLI fleet.

Frank died in 1997, at the age of seventy-six. Today, Elvas are much sought-after collectors' items.

An Elva Climax racing at Sebring, Florida. (Kurtz Patterson)

An Elva Courier road car. (Stphiliben under Creative Commons)

Fire Brigade

The members of Bexhill's volunteer fire brigade, formed in 1888, were heroes to the townsfolk and put on popular displays in which prizes were awarded to individual firemen by Viscount Cantelupe. He caused uproar at the 1892 event when, unhappy with the performance, he said he would replace the brigade's captain.

The men refused to accept this and, in retaliation, Cantelupe declined to give out prizes. The volunteers resigned, and the brigade was reformed – with only one of its original members – and Viscount Cantelupe in charge.

The garage owner Louis Russell adapted the brigade's old horse-drawn and steam-powered Merryweather pump into the town's first motorised engine, and became known as 'Bexhill's father of the fire brigade'. Russell's Garage, in London Road, closed in 2011 after 112 years of trading.

The links between the brigade and Bexhill's first family persisted. In 1925 a new engine was named Diana, after Lady De La Warr. In 1935, Kitty Sackville, young daughter of Diana and the 9th Earl, would only present a bouquet to the Duchess of York, at the opening of the De La Warr Pavilion, if she could be accompanied by her friend, fire brigade captain Jim Stevens. Four years earlier, Kitty had had an engine named after her.

Franklin, Rosalind

A remarkable scientist dubbed the Dark Lady of DNA had a schoolgirl connection with Bexhill. Rosalind Franklin's work was central to the understanding of the molecular structures of DNA and viruses.

Rosalind (1920–58) spent two years at Lindores School for Ladies, Wrestwood Road, from the age of nine, sent there because the sea air of Bexhill would be good for her delicate health.

Franklin went on to study natural sciences and physical chemistry at Newnham College, Cambridge, where she was taught by two early pioneers of X-ray crystallography and molecular biology, W. C. Price and J. D. Bernal. Bernal said the X-ray photographs she later made of DNA were 'among the most beautiful ever taken'.

In 1952 Rosalind took a photo that provided the first proof that DNA was structured as a double helix. This evidence enabled Francis Crick and James Watson to go on to build their now familiar DNA double helix model.

Rosalind died tragically young, at the age of thirty-seven, of ovarian cancer which may have been caused by her prolonged exposure to X-ray radiation in the laboratory. Had she lived, it is likely she would have won a Nobel Prize, along with Crick and Watson.

In 2020 a commemorative 50p coin was issued to mark what would have been Rosalind Franklin's hundredth birthday.

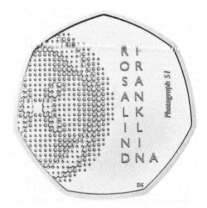

Right: A Rosalind Franklin commemorative coin.

Below: Speaking up for Rosalind Franklin. (Cyndy Sims Parr under Creative Commons)

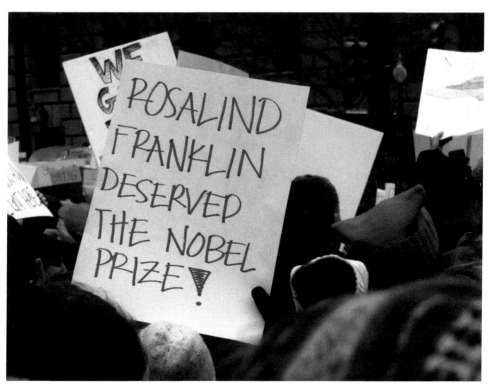

Gallows

The ghost of Bexhill's gallows keeper is said to haunt the area around the railway station, where the bodies of condemned criminals were exhibited for a period following their execution. His job was to keep the corpses in place on the gibbet for several days before their burial in an unmarked grave.

This was the site of public executions from the thirteenth to the nineteenth centuries. The ghost of the keeper reputedly walks from the station across to St Mary Magdalene's churchyard wearing a hooded cloak.

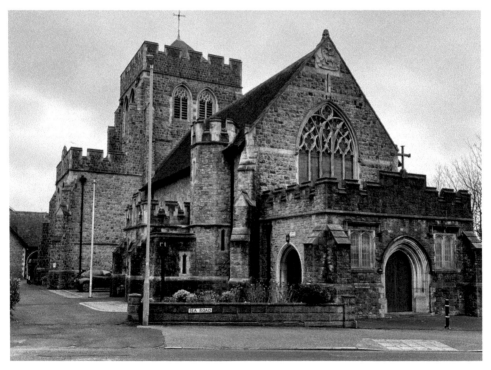

The ghost of the gallows keeper is said to haunt the area between the railway station and St Mary Magdalene Church.

Goodwin, Albert

The Pre-Raphaelite and Turner-inspired landscape artist Albert Goodwin lived in Bexhill for many years. He was mentored by John Ruskin, who took him on a Grand Tour of Europe.

Goodwin (1845–1932) was one of nine children of a Maidstone builder, and apprenticed to a draper. Yet he was a prodigy, demonstrating exceptional artistic ability at an early age, and was only fifteen when he first exhibited at the Royal Academy.

He left drapery to study with the Pre-Raphaelite artist Ford Madox Brown, who predicted Goodwin would become 'one of the greatest landscape painters of the age'.

In 1906 he moved with his wife and two daughters to Ellerslie Lane, where he lived for the rest of his life.

Goodwin travelled extensively to Switzerland, Italy, Norway and Holland, as well as the West Indies, India, Egypt, New Zealand and Australia. He produced over 800 works – mainly watercolours – and once wrote in his diary: 'nature has an endless storehouse to draw upon and to draw from'.

He was also inspired by the landscapes of Sussex and Kent. Among local works are a watercolour-and-pen view of Hoods Mill, *St Leonards from Galley Hill*, and a seascape *Spirit of the Storm*. Many show Turner's influence, and in 1911 Goodwin wrote in his diary: 'I sometimes wonder if the spirit of old Turner takes over my personality. I often find (or think I find) myself doing the very same things that he seemed to do.'

Goodwin's daughters Olive and Christabel stayed on in the family home, Christabel becoming a ceramicist specialising in pots and tiles, and opening the Highwoods Pottery on Turkey Road.

The Pre-Raphaelite and Turner-inspired landscape artist Albert Goodwin lived in Bexhill.

Green, Gustavus

When Gustavus Green moved to Bexhill in 1897 it was to set up as a cycle repairer and manufacturer at No. 5 Western Road. However, his ambition stretched far beyond the humble bicycle, and in 1905 he went on to design groundbreaking aircraft engines, including the one that powered pioneer aviator John Moore-Brabazon's prize-winning plane.

Lord Brabazon won £1,000 in 1909 when he became the first person to fly an all-British plane in a circular mile. He later took a piglet up with him, proving that 'Pigs might fly'. Green's engines powered other early aviators, as well as First World War torpedo boats.

Despite having no engineering training, Green (1865–1964) proved to be a brilliant engine designer. His highly reliable engines had a remarkable power-to-weight ratio, and were used by a wide range of aircraft manufactures including Short and Sopwith.

He founded the Green Engine Co. Ltd to sell them, with premises at No. 45 Reginald Road from 1902 to 1914. Having lived above the shop at Western Road, Green moved to No. 49 Reginald Road in 1903, and a few doors down to No. 35 in 1908.

Gustavus also designed engines for motorcycles and high-speed motor launches. After the Second World War he designed inflatable rubber decks for aircraft carriers on which planes could land without the need for an undercarriage.

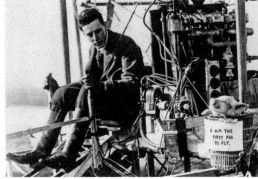

Above: Gustavus Green's engines powered early aviators including Lord Brabazon.

Left: Gustavus Green's first workshop was at No. 5 Western Road.

H

Hare, David

The distinguished playwright, screenwriter, theatre and film director David Hare was brought up in Bexhill. His memoir, *The Blue Touch Paper*, relates his 1950s childhood memories of the town, and his days at Pendragon School in Cantelupe Road and Harewood School in Collington Avenue.

In contrast to Eddie Izzard's (see separate entry) recollections of an idyllic place in the 1970s and 1980s, Hare paints a much bleaker portrait from twenty years earlier.

He lived with his parents Nancy and Clifford at No. 34 Newlands Avenue, a street he calls 'almost a parody of suburbia'.

He says: 'For any young person, the words "Bexhill" and "boredom" were joined at the hip ... there was nothing to do except fantasise about getting away.' Bexhill 'seemed

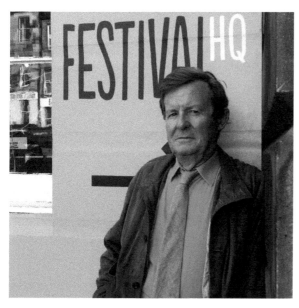 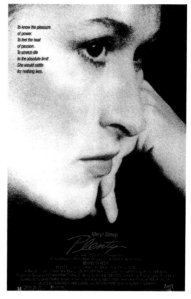

Above left and above right: The Bexhill-raised playwright David Hare wrote *Plenty*, starring Meryl Streep. (Peter Burnett under Creative Commons)

to be in a sort of dormitory coma, as though John Wyndham's triffids had just passed through and stunned the population ... Even the cawing seagulls seemed stunned into silence after lunch.'

Hare found the place oppressive:

How do I begin to explain the level of repression obtaining in Newlands Avenue, where to hang your washing out on a Sunday or to fail to polish your car on a Saturday invited – well what? The opprobrium of your neighbours? Or maybe just the imagined opprobrium, which could well, in the latent hysteria of the silent street, be twice as bad.

He was forbidden from watching downmarket ITV, or from buying penny chews and Wagon Wheels from the Cosy Cafe in Sea Road. When Marty Wilde, 'the insipid rocker of the mid-1950s' was scheduled to appear in a leather jacket and singing 'Teenager in Love' at the De La Warr Pavilion, Hare says, 'there were protests in the local paper'.

School was not all bad. At Pendragon he was taught piano by Philip Ledger, who knew Benjamin Britten and Peter Pears, and would later become director of the Aldeburgh Festival.

However, prestigious, regimented Harewood school 'brought out in me ... repellent consciousness of class status'. He was beaten up on the way home 'by a group of rough boys ... for no other crime but going to a private establishment and wearing its distinctive blazer'. The headmaster, Michael Philips, 'spent his day in a torment of self-feeding ill temper clawing compulsively at his crotch and driven mad, it seemed, by his pupils'.

In contrast Mr Palmer, headmaster of the less prestigious Normandale School next door, 'spent most of the day and a good part of his nights, pipe clamped between teeth, driving his state-of-the-art petrol lawnmower over his velvet turf. His Christmas card portrayed him on his machine.'

Bexhill did, however, spark Hare's interest in the theatre. There were repertory theatre companies at the De La Warr Pavilion and Devonshire Gardens. In 1957 the latter performed forty-seven plays during the summer season, 'over twice as many as now offered annually by our National Theatre', with works by Anouilh, Sheridan, Wilde, Maugham, J. B. Priestley, Arthur Miller and Graham Green.

Hare went on to receive Academy Award nominations for his screenplays for the movies *The Hours* and *The Reader*. He adapted his West End hit play *Plenty* into a film starring Meryl Streep, and has had a string of plays on Broadway and at the National Theatre. TV series have included *Page Eight* and *Collateral*.

Hare still finds Bexhill less than enjoyable. He writes:

If you visit ... Bexhill today, you will find only a smear of trendiness – pockets of painters, architects and designers loving the air and loving the sea, going into raptures over the choice little eruptions of modern architecture – laid over a

Ira

A ghost known only as Ira is said to haunt the stage of the De La Warr Pavilion. Ira (pronounced Era) appears with tied-back hair, wearing a blue Victorian-style dress and blue bonnet, and has been seen by cast, crew and audience members, sometimes surrounded in a blue haze.

One theory is that Ira lived in the coastguard houses that stood where the pavilion was built, and was killed by a jilted lover; another that she was a ballerina who died during a performance.

Ixion

Canon Basil Davies, rector of St Barnabas in Cantelupe Road, led a second, more energetic life away from his duties as a clergyman. He was a pioneering motorcyclist,

Right and opposite: Canon Basil Davies, rector of St Barnabas in Cantelupe Road, led a second life as Ixion, a motorcycling correspondent.

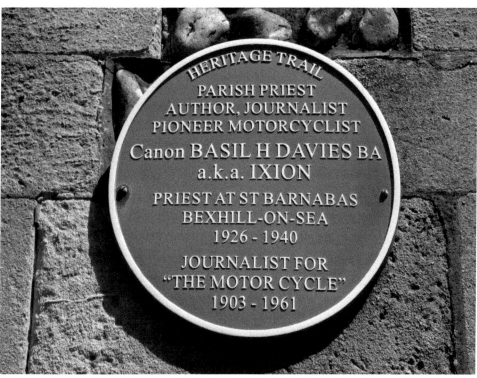

riding the earliest experimental machines in the 1890s, and wrote under the pseudonym Ixion for *The Motor Cycle* magazine from 1903 to 1961. He also broadcast on the BBC and gave the first live commentary from the Isle of Man TT races.

There is now an annual Ixion Run for pre-1940 bikes which passes the church Canon Davies served from 1926 to 1940.

Izzard, Eddie

Eddie Izzard grew up in Bexhill, and has championed the town ever since. *Believe Me*, Eddie's autobiography, deals extensively with that time, and shows great affection for the place.

Eddie was born in Aden in 1962, the family coming to Bexhill the following year. They left for stints in South Wales and Northern Ireland before settling in Bexhill for good in 1969. They lived for many years at No. 74 Cranston Avenue. Eddie's father and grandmother were both from Sidley.

The stand-up comedian, actor, writer, and activist is patron of Bexhill Museum, to which Eddie and brother Mark donated the family train set, and honorary patron of the De La Warr Pavilion.

In 2012 Eddie commissioned a replica of the bus that features in *The Italian Job*, the classic caper movie featuring Michael Caine, to be placed on the roof of the pavilion, as part of the Cultural Olympiad held at the time of the London Olympics.

The replica was positioned as if balanced perilously on the very edge of the roof, in a reference to the end of the film, when a bus is left hanging over a cliff.

Eddie boarded at St Bede's School in Eastbourne, then attended Eastbourne College before leaving for Sheffield University. In *Believe Me* Izzard recalls selling ice creams from a kiosk at the foot of Galley Hill in the summer holidays, working in the restaurant

Left and opposite top: Cranston Avenue was the childhood home of actor, writer and comedian Eddie Izzard. (Garry Knight under Creative Commons)

Below: Izzard sponsored this installation as part of the 2012 Cultural Olympiad. (Chris Sampson under Creative Commons)

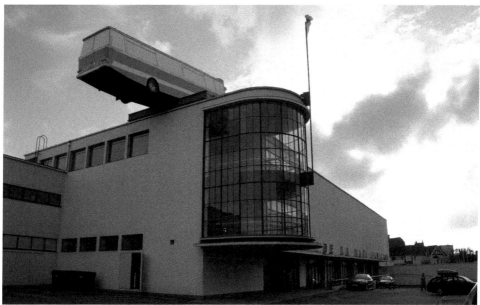

in the De La Warr Pavilion, and briefly in the kiosk in Egerton Park. Eddie remembers doing a paper round from Collington Post Office, and secretly buying a keyboard from Birds Music Centre in Sackville Road and smuggling it back to boarding school.

In 2019 Bexhill Museum created a further railway layout, featuring the town as Eddie's father Harold would have known it in 1940. Eddie funded the project and aimed to open it on Harold's ninetieth birthday. Sadly Harold died before that ambition could be realised.

Jamestown

When Thomas West, the 3rd Baron De La Warr, arrived in Jamestown, in the then colony of Virginia, the settlement was about to be abandoned. The year was 1610, and West had been appointed by James I as the colony's first governor. He brought food for the starving inhabitants, and ensured the survival of the settlement.

Virginia became the first enduring English colony in North America, sustained by growing and exporting tobacco, but West waged a brutal campaign against the native inhabitants. Illness forced him to leave for England in 1611, but he remained governor and captain-general of Virginia for life. He died in 1618 while on a voyage back there.

The Delaware Bay and Delaware River were named after him, and later the state of Delaware.

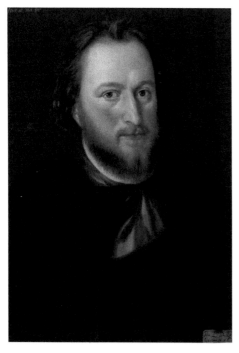

Thomas West, the 3rd Baron De La Warr.
(Jamestown Historical Society under Creative Commons)

Keane

The band Keane have featured Bexhill in their lyrics, song titles and album artwork. The cover of the album *Strangeland* was shot from the beach. The song 'The Sovereign Light Café' on that album references this and other Bexhill landmarks the group enjoyed visiting in their youth from their home town of Battle. It includes the lines:

> We'd go down to the rides on East Parade
> By the lights of the Palace Arcade
> And watch night coming down on the Sovereign Light Café

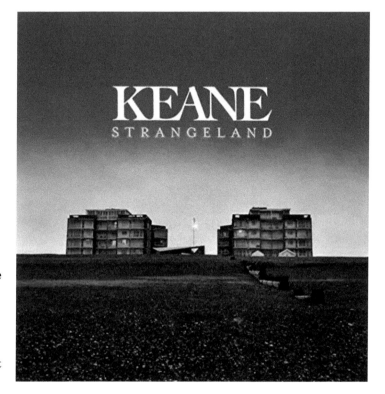

The band Keane have featured Bexhill in their lyrics, song titles and album artwork. The cover of the album *Strangeland* was shot from the beach.

Keane wrote a song entitled 'The Sovereign Light Café', after this Bexhill seafront institution.

The video made to accompany the song involves a parade along the promenade. Many locals took part in it, including members of the Classic Cycle Group, Bexhill Light Operatic and Drama Society, Bexhill Hootokan Karate Club, Bexhill Rowing Club, plus gymnasts, skateboarders and dancers.

The band say the song and video aim to 'create a portrait of a much-loved seaside town and joyful celebration of English life'.

The novelist William Boyd wrote a short story, also entitled 'Strangeland', to accompany the album after the band wrote 'Any Human Heart', inspired by Boyd's novel of that name.

William Boyd wrote in a *Guardian* article of his research trip:

> I went down to Bexhill to savour the atmosphere. Keane were due to play the De La Warr Pavilion as a kind of thank you to the locale that had nurtured and inspired them ... The place is redolent of a form of timeless English holiday ... I wandered up the promenade and had a sausage sandwich and a glass of chardonnay in the Sovereign Light Café ...
>
> Bexhill is very English and Keane's new album (straight to No 1. again) is rooted in this part of England. It's not parochial in any sense: it's more celebratory of the fact that life goes on here – in these out-of-season resorts – with the same intensity and passion, the joy and tragedy, the same mundanity and tedium, as it does anywhere else in the country – or in the world, come to that.

King of the Witches

Alex Sanders, high priest in the Pagan religion of Wicca, lived in Bexhill Old Town and held meetings in the De La Warr Pavilion.

The King of the Witches put a curse on a Bexhill Light Opera and Dramatic Society (Blods) production at the pavilion after his wife, who was their musical director, fell out with the producer. Sanders (1926–88) later claimed he had been joking, but the story of the curse appeared in newspapers around the world.

Since the 1960s, Sanders had enjoyed widespread notoriety and regular tabloid coverage. A film, *Legend of the Witches*, was made about him in 1970.

Above and right: King of the Witches Alex Sanders lived in Chantry Cottage, High Street, and held initiations in The Bell. (Dr-Mx under Creative Commons)

According to Jimahl di Fiosa's book *A Coin for the Ferryman: The Death and Life of Alex Sanders*, he moved to Bexhill from London in the 1970s after splitting with his second wife, Maxine. He came because Betty Britton, a woman he had initiated into his coven, invited him to move in to Chantry Cottage, her home in High Street, where he set up a temple.

By day he enjoyed scouring the many antique shops in Bexhill and bought and sold Wedgwood china. By night he went to The Bell pub in Church Street with a group of followers, and would on occasion form a circle in the bar and initiate newcomers. He organised open-air rituals, taking his paraphernalia to the beach in a taxi. He also met Gillian Sicka, a concert pianist, who became his third wife in 1982.

The row with Blods, in 1985, came about when Irene Spillen, producer of their performance of Frederick Norton's *Chu Chin Chow*, which tells the story of Ali Baba and the Forty Thieves, wanted to shorten one of the key songs.

In the *Bexhill Observer* Patrick Balchin reported: 'Gillian told the producer "you are a bitch and you will stay a bitch forever. The show is cursed".' The report continued: 'Gillian refuses to say what the curse is: "It's all very simple, but if you want to find out, you'll have to join the coven".'

A week later Balchin was able to report that local witches had met and removed the curse.

When Alex Sanders died of lung cancer, at the age of sixty-one, in 1988 his death certificate gave his occupation as 'occultist'.

Krishnamurti, Jiddu

When the Theosophical Society brought Jiddu Krishnamurti, a young Indian boy they believed to be the new Messiah, to England in 1911 he stayed with Countess Muriel De La Warr, wife of the 8th Earl, in Bexhill while they prepared him to become what they called the World Teacher.

Krishnamurti (1895–1986) was discovered in India by members of the Theosophy sect, a religion established in the United States in the nineteenth century that draws on Hinduism and Buddhism. They decided he had an extraordinary aura and groomed him as their leader.

Jiddu later rejected Theosophy, but became a philosopher and writer.

Kursaal, The

The Kursaal, built as an entertainment pavilion on De La Warr Parade in 1896, was intended to be the landward section of a pier, but the rest was never built.

The idea of building such a pavilion came from Daniel Mayer, a German theatrical agent, concert director and friend of the De La Warr family. He had moved to Bexhill the previous year for his health, and became a prominent citizen, helping develop the

town as a resort and serving four terms as mayor. Mayer stood down in 1914, at the outbreak of war, because of anti-German sentiment in the town.

From 1900 the Kursaal was managed by the musical director of Drury Lane, Jimmy Glover, who brought many major acts down from London. By 1908 it was struggling, and the 8th Earl De La Warr sold it. It was demolished in 1936, to be replaced in 1965 by the present sailing club headquarters.

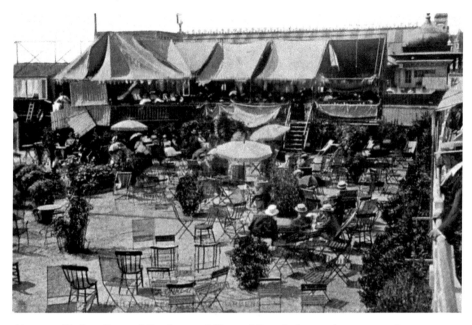

Above and below: Kursaal Gardens and Kursaal Parade featured on postcards.

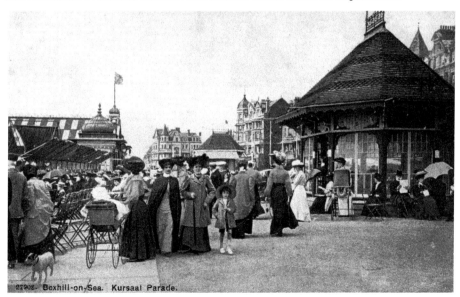

L

Lowry, L. S.

The artist L. S. Lowry visited Bexhill in 1960 on a painting trip, and captured the dilapidated Hoad's Mill in his 'Old Mill at Bexhill'. The mill, in Gunters Lane, has since been demolished, but the lower walls and millstones survive, at the junction with Old Mill Park, and Lowry's canvas belongs to Bexhill Museum.

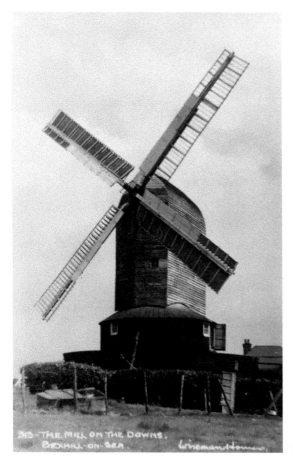

Hoad's Mill from an old postcard.

The remnants of Hoad's Mill today. (Dr-Mx under Creative Commons)

Longevity

Bexhill has a reputation for encouraging longevity. A dinner held in 1819 at the Bell Inn in the Old Town to mark the eighty-first birthday of George III was attended by twenty-five locals whose average age was eighty-one. There were also fifteen waiters at the age of seventy-one on average. Six bell-ringers who rang to mark the occasion averaged sixty-one years old.

The Bell enjoyed a longevity of its own, serving customers for 300 years before, sadly, closing in 2013.

Maharaja of Cooch Behar

The oriental-style bungalows of Marina Court, built in 1905, gave rise to an enduring myth: that they were built by the Maharaja of Cooch Behar to house his harem. In fact the maharaja (1862–1911) was monogamous, and only stayed briefly at No. 22 Marina Court in 1911.

He had been prince of the Indian state of Cooch Behar since childhood, and travelled to England to study. He came to Bexhill to convalesce after a bout of pneumonia, but sadly died.

The Maharaja of Cooch Behar lived in Marina Court.

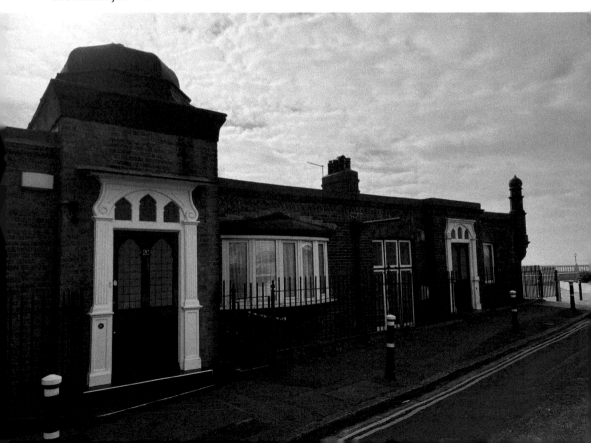

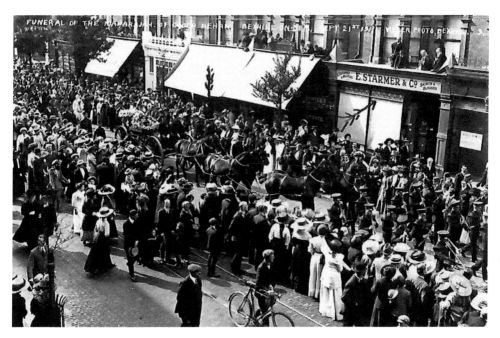

The Maharaja's funeral procession through Bexhill.

His funeral procession, from Marina Court Avenue to the railway station, was Bexhill's greatest-ever state occasion. His family donated a memorial fountain to the town, which stood on the present site of the De La Warr Pavilion, and it was moved to Egerton Park, then Bexhill Cemetery, where it went missing. Its present whereabouts are unknown.

A swimming pool or Turkish bath was planned for the central open area of Marina Court, but was never built. The eastern end housed the Cairo Toy and Fancy Depositary, with tea rooms, library and gift shop.

Manor House

Bexhill Manor House, the remains of which survive in the Old Town, was built by the Bishop of Chichester in around 1250. It was seized from the Church by William the Conqueror and given to his knight Robert, Count of Eu, who returned it to the bishops of Chichester in 1148. The manor house was rebuilt in stone around a century later.

It remained in the hands of the Church until Elizabeth I took possession and gave it to Sir Thomas Sackville, Earl of Dorset.

In the eighteenth century the house became a hunting lodge, used when the family went wildfowling, but their main homes were Buckhurst Place at Withyham, East Sussex and Knole House, at Sevenoaks, Kent.

The house was restored towards the end of the nineteenth century by Gilbert Sackville-West, who would become the 8th Earl.

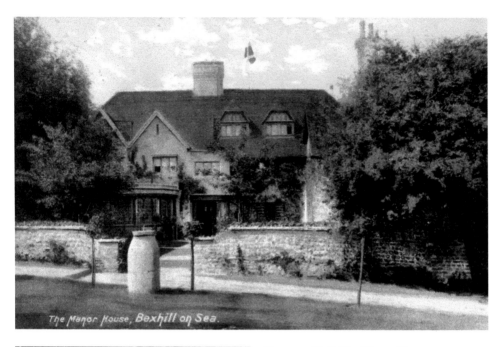

The Manor House, Bexhill on Sea.

Above and left: The Manor House was demolished to make way for a road, the grounds becoming a park.

The manor was demolished in 1968 so that the road through the Old Town – at the time the main road to Hastings – could be widened. Some outbuildings remain and the grounds are now Manor Gardens public park, with sections of the lower walls of the house retained as ornamental features.

Marley, Bob

The Reggae superstar Bob Marley (1945–81) performed his first UK gig at the De La Warr Pavilion, supporting Johnny Nash in an event organised by Bexhill Lions Club to raise money for the Glyne Gap swimming pool fund.

Marsden, Kate

Kate Marsden was a missionary and explorer who, in 1891, undertook an expedition to Siberia in search of a cure for leprosy, a debilitating disease that attacks the skin. She also happened to be gay, something the conditions of the time forced her to keep secret. When, in 1912, she planned to set up a museum in Bexhill, the mayor revealed the secret of her sexuality, and she was forced to resign.

Marsden's story is a remarkable one. Kate (1859–1931) trained as a nurse and, in 1877, volunteered with the Red Cross at the Russian-Turkish war in Bulgaria. There she came across victims of leprosy and was frustrated that there was little she could do to help them.

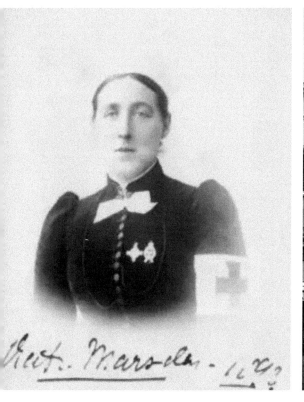

Above left and above right: Kate Marsden, co-founder of Bexhill Museum.

Kate Marsden covered thousands of miles in Siberia, searching for a cure for leprosy.

Two lepers convinced Kate that her mission in life should be to find a cure for the disease. It is a mark of her incredible determination and persuasive powers that she was able to gain the support of Queen Victoria and Princess Alexandra, and funding from the Russian royal family.

Her quest took her to Egypt, Palestine, Cyprus and Turkey where, according to her book *On Sledge and Horseback to the Outcast Siberian Lepers*, she met an English doctor in Constantinople who told her of the curative properties of a herb only found in Siberia.

With the support from Maria Feodorovna, Empress of Russia, who had previously presented her with an honour for her work in Bulgaria, Kate set out from Moscow on a year-long, 11,000-mile trek around Siberia with fifteen men and thirty horses. The plant she sought failed to offer a cure, but she did establish a leper hospital in Vilyuysk, and was a heroine to many.

Marsden became one of the first female fellows of the Royal Geographical Society, was presented with an angel-shaped brooch by Queen Victoria, and had her exploits serialised in the *Girl's Own* paper. She is still celebrated in Siberia, where a museum dedicated to her was established on the site of her hospital. A memorial statue was erected to Kate in 2014.

However, others questioned the truth of her account of her exploits. There were those who refused to believe a woman could have made such an arduous journey, and it was alleged she had misused funds donated for it. William Thomas Stead, editor of the *Pall Mall Gazette* and a pioneer of tabloid journalism, held her account up for

derision. She was called: 'That terrible fraud, Kate Marsden, the lady who makes such a comfortable living out of the leper rescue business.'

Many of the attacks seemed to be based on misogyny and hostility to her sexuality. In New Zealand, where Marsden had gone in 1884 to nurse her dying sister, it was suggested that the 'most trying mental illness' she suffered while there, and which caused her to take 'many backward steps' and to turn 'away from Christ', was a struggle with her sexuality.

In St Petersburg, Revd Alexander Francis claimed he had obtained a confession of 'immorality with women' from Kate. Lesbianism was not illegal, although homosexuality was, but the allegations were nevertheless deeply damaging. Kate sued Francis for libel, but lacked the funds to bring the case to court. An investigation was launched in Russia which cleared Marsden, and in 1894 British and American diplomats wrote to *The Times* in defence of her reputation.

By 1912, almost twenty years later, the scandal seemed long forgotten. Kate was living with two friends, the Norris sisters, Emily and A. M., at Silver Willows, No. 61 Dorset Road, and establishing a committee to found Bexhill Museum. The three women had been living together in various towns since 1902. She worked hard, together with fellow founder Revd J. C. Thompson, organising meetings to gather local support for the museum, and persuaded industrialists such as the match-makers Bryant and May and the confectioners Fry's to donate their collections. She also donated her own extensive shell collection.

However the mayor, Daniel Mayer, learned of the old scandal and informed the committee. Mr Thompson confronted Kate, asking her if there was any truth in the rumours of her sexuality, and she is believed to have said that there were. The Charity Organisation Society declared that Marsden was 'not a fit person to manage charitable funds' and she felt forced to resign.

Kate remained in Bexhill, living at No. 15 Cooden Drive, which she also named Silver Willows, in 1915 and, it seems likely, at Colebrooke Road in 1922. In 1925, now living in Hillingdon, west London, she suffered a stroke, which left her an invalid. In her later years she endured what was described as senile decay, and died at Springfield Hospital, Wandsworth, south London, the former pauper lunatic asylum, in 1931.

After her death, Emily Norris offered a photograph of Kate to Bexhill Museum. It was declined. However, it was later accepted and is on display.

Milligan, Spike

The comedian Spike Milligan did his Second World War military training in Bexhill, and the town features prominently in the first volume of his war memoir, *Adolf Hitler, My Part in His Downfall.*

Left: The late comedian Spike Milligan. (BBC)

Below left: Spike Milligan manned a post at Galley Hill during the Second World War. (Dr-Mx under Creative Commons)

Below right: Spike wrote about his Bexhill wartime experiences in *Adolf Hitler, My Part in His Downfall*.

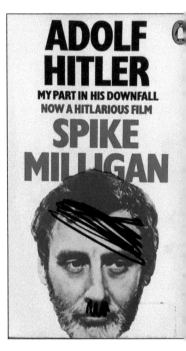

In the book, Spike describes reporting in June 1940 to D Battery, 56th Heavy Regiment Royal Artillery, which was billeted in Worthingholm, an evacuated girls' school in Hastings Road, later moving to The County School for Girls in Turkey Road.

Milligan (1918–2002) is sent to help man an Observation Post (O. P.) at Galley Hill, the stretch of cliff to the eastern edge of town. He describes 'sitting in a crude wooden

O. P. heaped with earth' and reproduces a sketch of the post, with coastguard and fishermen's cottages behind it. The cottages were demolished in 1974, but there is a concrete pillbox hidden in scrub. By some accounts this is the O. P. Spike refers to, since reinforced.

He is walking back to Worthingholm one night when he experiences 'my first confrontation with the enemy'. He writes:

> I heard the unmistakable sound of a Dornier bomber ... Suddenly, below me, coming out of the mist was the Dornier, flying low to avoid radar ... I could actually see the pilot and co-pilot's faces lit by a blue light on the instrument panel.

Spike is unarmed, but grabs the only weapon to hand, a brick, and hurls it at the plane. He misses.

D Battery was equipped with an obsolete First World War 9.2-inch howitzer, but no shells to fire from it. Eventually one is discovered, and plans are made to test-fire it out to sea. The day before, Spike writes 'we went round Bexhill carrying placards: "The noise you will hear tomorrow at midday will be that of Bexhill's own cannon. Do not be afraid".'

Townspeople were warned to open their windows to prevent shock waves shattering them. In fact, the shell proved to be a dud, falling into the sea with no more than a plop.

Milligan writes fondly if teasingly of Bexhill, describing the town as 'the only cemetery above ground'. He remembers swimming from the beach beneath the O. P., visits to the Forces Corner social centre at the junction of Sea Road and Cantalupe Road, going to the Picture Playhouse Cinema in Western Road (now a Wetherspoons), and drinking at The Devonshire in Devonshire Square.

Spike joined a jazz band and played at a Rotary Club dance at the De La Warr Pavilion. In 1941 he manned a military telephone exchange installed in a shelter at the back of Worthingholm. Long after the war, Milligan returned. He writes:

> In 1962 I took a sentimental journey back to Bexhill. The shelter was overgrown with brambles; I pushed down the stairs and by the light of a match I saw the original telephone cables still in place ... There was still a label on one. In faded lettering it said, 'Galley Hill O. P.' in my handwriting. The place was full of ghosts – I had to get out.

After the war, Spike found fame as a member of The Goons, whose surreal, anarchic BBC radio *Goon Show* was hugely popular in the 1950s. Spike scripted the shows, and Bexhill plays a starring role in an episode entitled 'The Dreaded Batter Pudding Hurler of Bexhill-on-Sea'.

Milligan never forgot the town, and organised regular reunions here for his former comrades. The Prince of Wales, a big Goons fan, attended one at Manor Gardens in 1988.

Motor Racing

The first British motor car race was held in Bexhill. The 8th Earl Sackville, a committed moderniser, had brought the 1890s craze of cycling to the private promenade in front of The Sackville, creating a Bicycle Boulevard where international cycling tournaments were held.

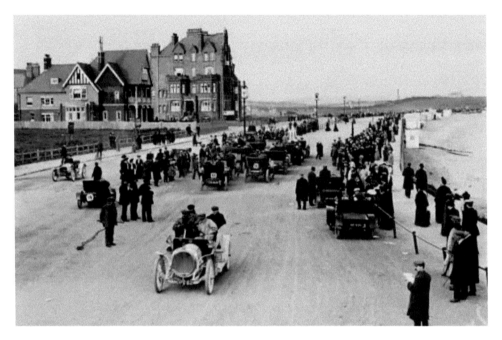

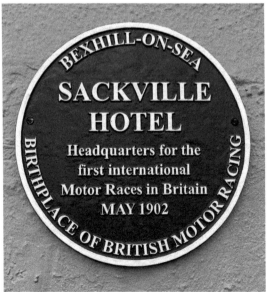

Above and left: Bexhill's motor-racing heritage is marked with a plaque.

Dorothy Levitt raced at Bexhill and wrote a guide for women drivers.

In 1902 the Earl presciently decided that the motor car was the coming thing, and turned his bicycle promenade into the country's first motor racing track, realising that on private land cars were exempt from the inhibition of the 12 mph speed limit in force on public roads.

When cars became too fast to race along the promenade, and plans for an 8-mile racetrack on the marshes at Pevensey came to nothing, concourse d'elegance events were held instead. Brooklands became the home of British motor racing, but Bexhill's connection with cars has persisted, and motoring festivals are held annually.

Among the stars at Bexhill in 1907 was Dorothy Levitt, the first British woman racing driver. Levitt (1882–1922) held the women's world land speed record and was dubbed 'the Fastest Girl on Earth', and the 'Champion Lady Motorist of the World'. She taught Queen Alexandra and the royal princesses to drive, and inspired many other women through her example, and her practical guide *The Woman and the Car: A Chatty Little Handbook*.

In it she recommended carrying a hand mirror that could be held up to see what was behind you, thus inventing the rear-view mirror; and for women travelling alone to carry a handgun, preferably a Colt automatic, which had very little recoil.

She died at the age of just forty, of morphine poisoning. At the time she was suffering from heart disease and measles, and a verdict of misadventure was recorded.

Murder

The brutal murder of a nurse, the goddaughter of Florence Nightingale, was discovered in Bexhill in 1920. Florence Nightingale Shore was found semi-conscious on a train as

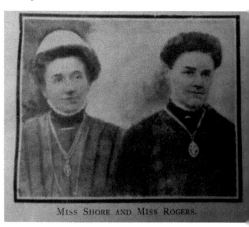

MISS SHORE AND MISS ROGERS.

Left and below: Florence Nightingale Shore was found mortally wounded at Bexhill railway station.

it arrived at the town's main station. She had been viciously attacked, and died four days later in hospital. Her killer was never found.

Florence was travelling, on a bitterly cold afternoon in January, from London Victoria to Hastings. She was seen off by her friend Mabel Rogers. Just as the 3.20 p.m. train departed, Mabel told the subsequent inquest a male passenger whose face she did not see got into the self-contained compartment.

The train stopped at Lewes and Polegate, where three workmen got into the compartment. It was dimly lit, and the men thought Florence was sleeping, with a veil over her face. Only as the train arrived at Bexhill did they see, in the station lights, that the veil was actually blood. They raised the alarm.

Florence had been clubbed on the head three times, perhaps with the butt of a revolver, but she was alive. She was taken to Hastings Hospital, where Mabel Rogers sat at her bedside. Sadly, she did not recover.

N

Nazareth House

Nazareth House was established in Wrestwood Road in 1893 as a home for 'poor and destitute and orphaned children', mainly girls. In 1953 two girls drowned while on a school bathing trip to the beach at Glyne Gap. Ten-year-old Frances McCarthy and Janet Dover, aged eleven, were engulfed by a heavy wave.

An inquest heard that, of the sixty girls in the group, only a handful were good swimmers, and only three adults were on hand to supervise them as they swam, at a location made treacherous by dangerous rocks. The coroner ruled that this amounted to lack of proper supervision, and a verdict of accidental death was returned. Nazareth House is now apartments.

Nazi Girls' School

The story of a Nazi girls' school in Bexhill in the 1930s so intrigued Eddie Izzard (see separate entry) that he made a film about it. His interest was sparked when Julian Porter, curator of Bexhill Museum, showed him the only surviving school badge, which featured a swastika alongside the Union Jack.

The Augusta Victoria College in Dorset Road was attended by – among others – Bettina von Ribbentrop, daughter of Hitler's Foreign Minister; Himmler's goddaughter; and Isa von Bergen, daughter of Hitler's envoy to the Vatican.

The school was named after Augusta Victoria of Schleswig Holstein, wife of Wilhelm II, the last German emperor. Flats now occupy the site, No. 128 Dorset Road.

Izzard plays an English teacher in the film, *Six Minutes to Midnight*, which he scripted, and which also stars Judi Dench and Jim Broadbent.

As part of his research, Eddie interviewed Mollie Hickie, an English woman who worked as a chaperone at the school from 1935 to 1939. Mollie, who died in 2014, donated the school badge and only known surviving prospectus to the museum.

At the time it was believed by many that the presence of the daughters of high-raking Nazis in England made war with Germany less likely. Others were less sanguine, and there were rumours that the school was a front for a Nazi spy ring.

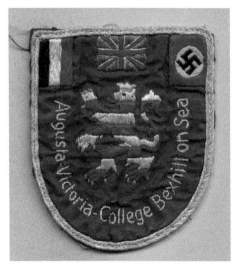

Left and below: The badge of
Augusta Victoria College featured a swastika.
(Bexhill Museum)

In *The Story of Bexhill's Pre-war Nazi Girls' School* Julian Porter says such stories are false, but that the school's 'role was more subtle and much more insidious'. The article continues: 'These were Nazis hiding in plain sight, helping establish Hitler's hoped-for future relationship between the British Empire and the Third Reich.'

Certainly, the *Bexhill Observer* covered the school's activities as if they were entirely innocent. In 1937 the paper reported on a visit by pupils to the German Embassy in London, where they met Field Marshal Werner von Blomberg, Hitler's Minister of War. The report read:

Flats now occupy the former school site in Dorset Road.

> Their healthy sunburned bright faces were all raised to the tall marshal as he
> asked them about the college and their studies in England ... The youngest student
> presented a bouquet of carnations, while the others greeted him with the Nazi salute.

The girls came to Bexhill, according to Revd F. E. England, minister of Bexhill's
Presbyterian Church, quoted in the *Observer*, 'in order to get an insight into our
English life and understand us, and to give us an opportunity of understanding them'.

However, others saw the threat from Germany as very real. In February 1939 Earl
De La Warr went to Paris to marshal support for an Anglo-French alliance against
Nazi aggression. He had previously commissioned the German-Jewish refugee
architect Erich Mendelsohn to design the De La Warr Pavilion.

Two months later the school blithely celebrated Hitler's birthday, singing National
Socialist songs and running the swastika up the school flagpole.

In May, the school's principal, Frau Helena Rocholl, told a reporter from *The Sunday
People*: 'There's not going to be a war. There is no need for panic of any kind, and it's
lessons as usual here.' As a mark of her confidence, she even planned to open a boys'
school. However, on 26 August, pupils and staff fled to Germany. A week later, war
was declared.

In 2017 Izzard brought Dame Judi to Bexhill for lunch at the De La Warr Pavilion
to discuss the movie and plans to film in Bexhill. In fact it was shot in Wales, and
released on Sky Cinema in March 2021. Anti-Covid restrictions meant that the
planned premier at the De La Warr Pavilion had to be scaled back to an online event.

Offa, King

Bexhill received its town charter from King Offa in 772. He had subjugated the Haestingas, Christian colonists who had moved into the Bexhill region of Sussex from Kent, the previous year.

Operation Sealion

In the summer of 1940 Hitler drew up plans to invade England. The operation was code-named Operation Sealion, and Bexhill was at its focal point.

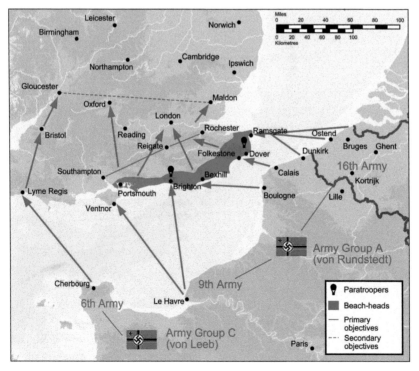

Bexhill was at the focal point of Operation Sealion, Hitler's plan to invade England. (Wereon under Creative Commons)

A coastal defence battery at Normans Bay. (Dr-Mx under Creative Commons)

A Second World War personnel shelter in Sea Road. (Dr-Mx under Creative Commons)

The plan was formulated shortly after the ignominy of Dunkirk, when 340,000 retreating Allied forces had to be rescued from the beaches by a flotilla of 800 Little Ships.

Hitler hoped a speedy surrender would follow but, when it failed to materialise, he issued a directive which read:

> As England, in spite of the hopelessness of her military position, has so far shown herself unwilling to come to any compromise, I have therefore decided to begin to prepare for, and if necessary to carry out, an invasion of England.

By August a plan was in place to use a naval force of 1,900 barges, 168 merchant ships and many other craft to land nine divisions (173,000 men) in a three-day operation. Tides and moon offered two windows of opportunity: 20–26 August and 19–26 September.

The assault would be spread along the south coast, from Ramsgate to Lyme Regis. Bexhill, positioned at the central point between the two major invasion zones, would be a crucial communications hub, and plans were laid to capture and hold the town while other forces pressed inland towards London, the ultimate goal.

Defences at the time were weak. An inspection in June had concluded that the beaches of Eastbourne, Bexhill and Hastings were highly vulnerable. Once ashore, there was little to stop any advance. The territory up to the South Downs was the responsibility of the Home Guard, which had few resources: little more than light arms and makeshift barricades of barbed wire and tree trunks with which to resist the might of the German military machine.

Under Hitler's plans, which Peter Schenk studied for his book *Operation Sealion: The Invasion of England 1940*, the German 38th Army would land between Bexhill and Eastbourne. The 34th Division would come ashore on Cooden Beach: around 20,000 men, over 1,500 vehicles, forty tanks, seventy-five anti-tank guns and other weapons, plus 4,000 horses to shift artillery.

They would be faced by just twenty gun emplacements, a double row of tank traps and landmines. Once past these, the tanks would mount a three-pronged attack, the western prong advancing past Wartling to Windmill Hill; a central one forging past Hooe to north of Ninfield, the eastern going inland to Lunsford's Cross, turning east and then south to attack Bexhill from the rear, through Sidley.

This third prong's mission was to capture and hold Bexhill. There would also be a frontal attack under a blanket of smoke from a fleet of small boats.

Not all enemy soldiers would be in German uniform. Special forces of English speakers in captured British Army battledress, and driving British motorbikes, would seek to infiltrate the defences.

If invasion had taken place, the first shots in the battle for Bexhill would have been fired at Sidley. A brutal, urban-warfare fight to the death would have followed, the defenders resisting street by street, house by house. Five areas of the town would be fortified as individual but connected strongpoints, the inhabitants evacuated, and the defence of Bexhill conducted from within them.

They were, at the back of town, the Highlands area to the north of Turkey Road, plus the area south of the A269 Ninfield Road in Sidley; the strategic road junction at the Wheatsheaf roundabout on the A259 in Little Common; the area south from Cooden Drive to the sea; and the town centre between the seafront and just north of the railway line in Magdalen Road.

However, with the German Navy failing to gain supremacy in the English Channel, and the Luftwaffe failing to prevail in the Battle of Britain, the invasion plan came to look decidedly shaky. The August dates passed without incident, and Hitler had a deadline of 17 September to decide whether the 19–26 September window was to be used. In the event, he approved the order 'Sealion: Postponed Until Further Notice.'

From Churchill's memoirs it is clear he did not see Operation Sealion as a realistic threat, but the fact that everyone in England was braced for a battle to the death, and it had been called off, felt like a great victory, and the first defeat for Hitler.

P

Pankhurst Mill

There were several windmills in the little agricultural settlement of Sidley. The last to survive, Pankhurst Mill, dated from 1813, but was dismantled and taken to Leigh in Kent in 1928, and collapsed in 1960.

Bexhill Local History Study Group's analysis of street names suggests that, from Mill View Road, a range of mills would have been visible, including Black Mill, Hoad's Mill (see entry for L. S. Lowry), Mount Idle Mill and Putlands Mill. Several street names refer to the mills that once stood in the vicinity. Black Mill gives its name to Blackmill Close, Cumberland Mill to Cumberland Close.

Powell, Don

Don Powell, the drummer in Slade – who had a string of No. 1 hits in the 1970s – lived in Bexhill for fifteen years, until 2004, with his then wife Joan Komlosi, a BBC journalist.

Don said that, when he played the town: 'It's a bit like when we used to play Wolverhampton in the 1970s. You tend to recognise most of the people out there.'

In 2015, when Don played Hastings, he wrote in his diary: 'Great gig. The support band were The Rockitmen and their guitarist was an electrician who used to do work for me when I was living in Bexhill! Also at the gig was Dave and Hazel Hanley. Dave used to service my cars.'

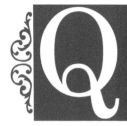

Q

Desmond Llewelyn, the actor who played the character Q in seventeen Bond films, lived in Bexhill from 1965 until his death in a road accident in 1999. He lived in Osborn House, High Street, in the Old Town.

He moved to Bexhill with his wife Pamela in 1938. The couple had met while he was appearing on stage in the town.

Desmond Llewelyn, the actor who played the character Q in seventeen Bond films, lived in Osborn House, High Street.

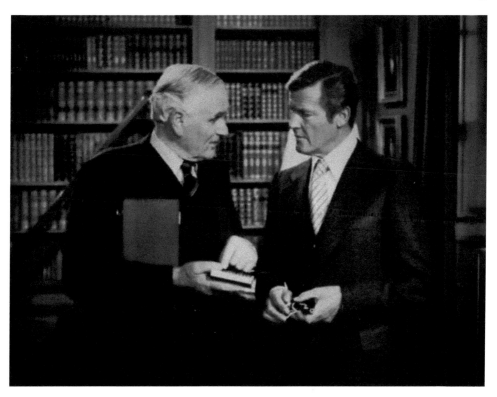

Desmond Llewelyn in a scene with Roger Moore as James Bond.

Desmond, born in 1914, was cast as Bond's armourer in *From Russia With Love*, released in 1963, and appeared in every subsequent Bond film, apart from *Live and Let Die*, up to *The World Is Not Enough*, released in the year he died.

The inquest into his death heard that he crashed his Renault Megane while attempting to overtake another car on the A27 near Firle. Mr Llewelyn's son Justin, who lived in a house opposite his father's, said that among the thousands of cards and letters of condolence were messages from all five Bond actors he appeared alongside: Sean Connery, George Lazenby, Roger Moore, Timothy Dalton and Pierce Brosnan

In an obituary, *The Guardian* reported that, 'while Bond films made him an internationally known face, they denied him other acting work because producers thought him too closely associated in the public's mind with Q; while the financial rewards of Bond were not nearly as great for him as the public assumed'.

Desmond was paid £400 a day for early appearances, and was only on set for three or four days, while the films made many millions. His obituary records: 'In the late Eighties, when the producers and stars were multi-millionaires, he claimed to be "skint" and living entirely off his state pension.'

Pamela Llewelyn died in 2001, and Justin in 2012. In 2000 the *Bexhill Observer* announced that the Desmond Llewelyn Cup would be awarded annually to the individual or group considered to have made a special contribution to the arts in Bexhill.

Railway

When the railway came in 1846, Bexhill was just a small village well to the north of the line and, initially, only a simple country halt was established, roughly where Sainsbury's car park is today. It was replaced by a new station, on Devonshire Square,

Left: The former Bexhill West railway station.

Below: Sidley station is long gone, with the Bexhill to Hastings link road running along the trackbed.

22968 Sidley. Railway Station and Pelham Hotel.

The Bexhill West branch line was closed under the Beeching cuts of 1964.

in 1891. In 1902, a larger station was needed. It was built on Sea Road, its platforms being joined on to the existing ones on Devonshire Square.

Also in 1902, the Bexhill West branch line was built, giving the town a fast link to London via Crowhurst, with new stations at Sidley and Bexhill West, where the line terminated. The line was closed under the Beeching cuts of 1964. The long, elegant viaduct that took it over the Coombe Valley was demolished with explosives in 1969. Bexhill West station is now an antiques gallery; the one at Sidley has been demolished. The Bexhill to Hastings link road was built along the old trackway through Sidley in 2015.

Royal Sovereign Light Tower

The distant shape of the Royal Sovereign Light Tower, seen shimmering on the horizon 8 miles out to sea, was anchored there in 1971 and became a Bexhill landmark. In misty weather its fog horn could be heard booming out across the waters.

However, in 2021 it was decided by Trinity House that it should be removed, with dismantling scheduled for 2022.

The tower, a warning to shipping of the treacherous Royal Sovereign Reef (or Shoal) replaced the Royal Sovereign Lightship, which had been in place since 1875. The crew left in 1994 when it became fully automated. Beachy Head Lighthouse, plus two offshore buoys, were upgraded to ensure the continued safety of mariners.

The reef takes its name from HMS *Royal Sovereign*, almost wrecked there in the seventeenth century. The sandstone and chalk seabed supports a rich habitat, and is home to the common oyster, the short-snouted seahorse and the thornback ray, a kite-shaped flat fish that feeds on crustaceans.

Left and below: The Royal Sovereign Light Tower replaced a light ship dating from 1875. (Geograph under Creative Commons)

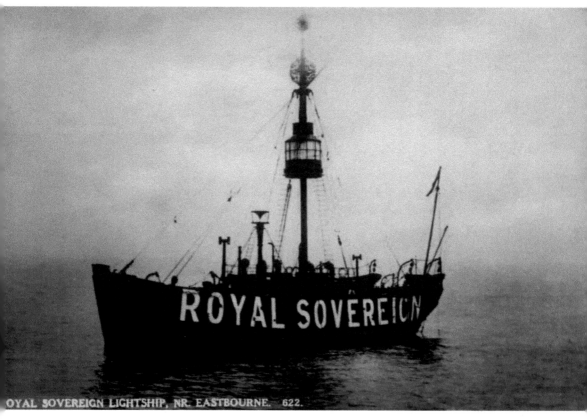

OYAL SOVEREIGN LIGHTSHIP, NR. EASTBOURNE. 622.

S

Sachs, Andrew

The actor Andrew Sachs, the hapless Spanish waiter Manuel in *Fawlty Towers*, was stage manager and made his stage début at the De La Warr Pavilion in 1947.

Sackville Family

Elizabeth I gave Bexhill to Sir Thomas Sackville in 1561, and his descendants continued to make their mark on the town into the twentieth century. In 1813 Elizabeth Sackville

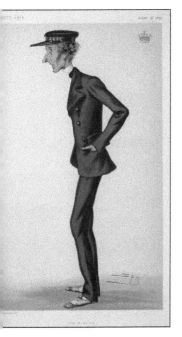

Above left: Reginald, 7th Earl Sackville in a caricature by *Spy*.

Above right: The Earl made his family home in the eastern half of the Sackville Hotel.

married the 5th Earl De La Warr, bringing two very influential families together. The Earl was a West, and put his wife's surname before his own, becoming the Sackville-Wests.

The 7th Earl, Reginald, turned Bexhill into the fashionable resort of Bexhill-on-Sea, exploiting the arrival of the railway. He had the commanding Sackville Hotel built and, as a sign of how closely the family was prepared to associate itself with the town they were creating, made the eastern half of the building their palatial home. The 8th Earl, Gilbert, was a committed moderniser who brought motor racing (see separate entry) to the town.

The 9th Earl, Herbrand, was another pioneer, and championed the creation of the De La Warr Pavilion. Herbrand – known as Buck – was, unusually for an aristocrat, a socialist, vegetarian and pacifist. He was the town's first Labour mayor and became the first hereditary peer to represent the Labour Party in Parliament.

The current Earl, the 11th, is William Herbrand Sackville, born in 1948.

Scandal

The marriage in 1891 of Gilbert Sackville, 8th Earl De La Warr, and Muriel Brassey, daughter of a fabulously wealthy railway contractor, might have seemed like a match made in heaven.

Both had much to gain from the union. She got a grand title, and he got her money, which he needed to fund his ambitious plans to make Bexhill a truly modern resort.

However, Gilbert was unfaithful, running off with Miss Turner, an actress he met at the Kursaal. Muriel divorced him for adultery in 1902, moving, by some accounts, into

Frances Osborne wrote a biography of her notorious ancestor, Lady Idina Sackville, who became known as The Bolter.

a house called Sackville Lodge that stood on Galley Hill. Muriel (1872–1930) became an active suffragette and social reformer. She funded the campaigns of George Lansbury, a politician who would go on to lead the Labour Party, and through him financed the launch in 1912 of the Labour-supporting *Daily Herald*.

Gilbert later married Hilda Tredcroft, the daughter of a colonel, but strayed again. In 1914 she divorced him, on the grounds of adultery and desertion. He was having an affair with Mabel Loeb, wife of the assistant manager of a London theatre, the Alhambra.

He also had money troubles and, when the First World War broke out, bought a commission and left the country, evading his creditors. He died of fever in 1915.

The thread of scandal ran down to the next generation, and Gilbert and Muriel's eldest daughter, Lady Idina Sackville. She was a member of the hedonistic, promiscuous Happy Valley set who settled in colonial Kenya and Uganda in the 1920s to 1940s. Idina, notorious for her relentless affairs and wild sex parties, married and divorced five times in rapid succession, and became known as The Bolter.

She is said to have been the inspiration for the novelist Nancy Mitford's character The Bolter in *The Pursuit of Love*, and the wild party girl Agatha Runcible in Evelyn Waugh's *Vile Bodies*.

In 2008, Idina's great-granddaughter Frances Osborne wrote a biography of her ancestor, entitled *The Bolter*.

Smuggling

Smuggling was rife from 1700 to 1850. Brandy, tobacco and other highly taxed goods were brought in and spies, newspapers and letters smuggled out. In 1828 the deadly Battle of Sidley Green took place, between 300 smugglers of the Little Common Gang and men of the Coast Blockade.

The New Inn, Sidley, a former smugglers' haunt.

The smugglers were interrupted as they unloaded a boat on the beach, and a running battle ensued that reached its fatal climax at Sidley Green, where the New Inn was their haunt.

There were many serious injuries and two deaths, one on each side. Most of the smugglers escaped with their contraband, but ten were arrested and transported to Australia. There is a village named Bexhill near Sydney, perhaps as a result of transported men settling here.

Spray, Arthur

Arthur Spray, who styled himself 'the mysterious cobbler of Bexhill', gained an extraordinary reputation as a faith healer when, in 1935, he wrote a book that was serialised in the *Sunday Dispatch* newspaper. In it he claimed to have had important doctors, scientists, millionaires and titled people visit his little shop at No. 16 Station Road, where he cured them of rheumatism, warts and migraines; improved eyesight; and banished cataracts by licking them off.

Many Bexhill residents swore Spray (1890–1961) had cured their illnesses, but his penetrating gaze led others to refer to him as Spooky Spray. He insisted: 'I am not

Above left and above right: Arthur Spray, 'the mysterious cobbler of Bexhill', had this shop in Station Road.

a Spiritualist, nor am I a yogi. I am just a shoemaker.' He complained: 'Many of my family think that I am a freak, or a friend of the devil.'

Spray tells his story in *The Mysterious Cobbler*. He was born in The Black House at Sprays Cottages, Sidley, in 1889, the thirteenth child of a poor family, whose father died when Arthur was just thirteen months old.

He first learned of his powers when, after the First World War, he was taking money to a sick veteran and the man insisted on holding his hands for a prolonged period. He said he did so because Arthur had healing hands.

Others learned of Spray's powers and asked him to heal them. A friend told Arthur about the power of hypnosis and, next time he was asked to help, rather than just taking the patient's pain away, he put her into a deep sleep. He had to get the friend to show him how to bring the woman round again. After that, hypnosis became a key part of his healing. He started to take payment for his services, and opened a consulting room above his shop.

In trying to explain how he was able to heal people, Arthur said: 'So far as I differ from the average man, is that I have a terrible power of concentration ... I am not a religious man in the ordinary sense ... I always say my power comes from God.' He sees God as 'a huge wireless broadcasting station in a universe of vibrations of thought.'

Arthur met his future wife, Alice, when she came into his shop to collect some shoes while suffering from a piercing headache. She was in service, and had come to Bexhill believing she had only three months to live.

Arthur offered to help with her headache and, as he pressed his hands to her head, uric acid crystallised on his fingers. Alice came back for regular treatment and was restored to good health. Alice also proved to have healing powers and so, Arthur writes, 'thus began a psychic partnership'.

The partnership worked like this, Arthur said: 'I never see anything unusual, feel anything out of the ordinary, or hear anything – except through Alice.'

Alice would go into a trance as she diagnosed a patient's ailment, and then direct Arthur as he performed the healing process. She was able to absorb illness from others, and Arthur described her as being like a sensitive wireless set, picking up vibrations from other people.

The identity of Alice remains a mystery. Her real first name may have been Daisy, but her full identity is something Arthur Spray took with him to the grave. He died peacefully in his sleep at his home in No. 33 Salisbury Road.

Strong, Gwyneth

The actress who played Cassandra Trotter, girlfriend and later wife of Rodney in the classic BBC comedy *Only Fools and Horses*, lives in Bexhill. She moved here with her actor husband Jesse Birdsall, star of *Footballers' Wives* and *Eldorado*, and campaigns for Ovarian Cancer Action.

Town Centre Redevelopment Plans

On two occasions radical plans have been drawn up for the town centre to be transformed through redevelopment.

In 1930 the General Development Plan, designed to give the town a defined centre for the first time, was created by the modernist architectural practice of Adam, Thompson and Fry. They proposed the demolition of the town centre and reconstruction in a modern style. The scheme also introduced the idea of a pavilion on the seafront, the only element to reach fruition, but the practice was unsuccessful in its bid to design the De La Warr Pavilion.

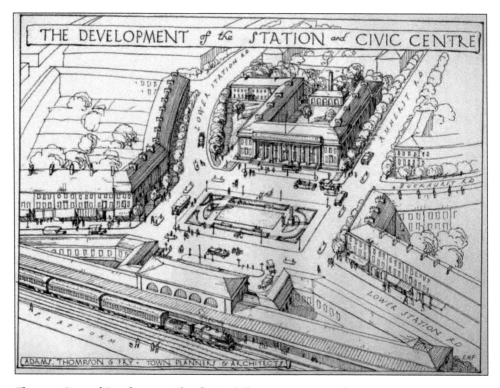

The 1930 General Development Plan for Bexhill was never enacted.

In 1967, a plan was again hatched to demolish the whole of the central area, replacing it with tower blocks, and suspending a multi-storey car park and office building above the railway line, as a way of linking the two sides of town. If the plan had been approved, the De La Warr Pavilion would have been the oldest building left standing on the seafront.

Two Minutes' Silence

The tradition of observing two minutes of silence to mark the signing of the armistice has a Bexhill connection. Major Nugent Fitzpatrick, who had been stationed at Cooden Camp with the South African Heavy Artillery, was killed in France in 1917. It was his father, Sir Percy Fitzpatrick, who suggested the idea to George V.

Typhoid

Bexhill suffered a serious outbreak of typhoid in the summer of 1880, and thirty-six died, endangering the reputation of the burgeoning resort. A contaminated well was blamed, and the incident led to the creation of a Local Board of Health.

Unexploded Bombs

Unexploded bombs, a legacy of the time when Bexhill lay in 'bomb alley', are still occasionally unearthed in the town, with bomb disposal squads called in to deal with them.

At the outbreak of the Second World War, Bexhill was considered a safe place for children, and 700 were evacuated from London. That changed in 1940, when air raids became frequent.

In total, 1,000 fire-starting incendiary bombs and 450 high-explosive bombs were dropped on the town in sixty-three air raids. Not all exploded. Some became buried and, occasionally, builders come across one of these still-deadly weapons.

In May 2009, 400 pupils had to be evacuated from St Peter and St Paul Church of England School in Buckhurst Road when a digger on the building site next door struck metal, scraping a layer of rust from what proved to be a 30-lb bomb, and exposing the nose cone.

The bomb was placed in an 8-foot-deep pit, dug in the centre of the site, and detonated in a carefully controlled explosion.

A map showing where bombs fell was printed in the *Bexhill Observer* in 1944. It shows a cluster of three hits at the top of Buckhurst Road.

In September 2020, a builder found a mortar shell beneath a patio he was digging up in Collington. A Royal Logistic Corp team took it to Little Common Recreation Ground and safely detonated it.

A further wartime threat came from unmanned V-1 flying bombs which passed overhead on their approach to London. For almost eighty days, inhabitants held their breath as they heard the whine of the V-1s flying overhead. In one terrifying twenty-four-hour period around fifty were tracked.

V

Vieler, Herbert

Herbert Vieler was a pioneer of the popular art of postcard photography. Between 1910 and 1930 he produced thousands of images of the town which visitors sent as records of their time at the seaside.

Vieler (1878–1950) moved to Bexhill as a child with his father Emil, also a photographer, and worked initially as his assistant. For fifteen years they had a studio at No. 11 Upper Station Road before, in 1911, Herbert struck out on his own, with premises at No. 26 Station Road, which he named Imperial Studios.

Herbert worked as an outdoor photographer as opposed to doing studio portraits, and hence captured every aspect of the life of the town and its people,

ROUGH SEA, BEXHILL—ON—SEA.

Herbert Vieler's postcards of Bexhill, including this of rough seas, were hugely popular with visitors.

from news stories, street processions and shows, to weddings and other family events.

As postcards, his photographic views of the seafront, parks, churches and other landmarks were hugely popular.

Volta

In 1993 students at St Richard's Catholic College set a new land speed record for an electronic car with their vehicle *Volta*. The car is displayed at Bexhill Museum.

It was made by four pupils under the guidance of Peter Fairhurst, a technology teacher, and achieved 106.74 mph in a time trial at the RAF base at Greenham Common, Berkshire. It beat the previous record of 100.242 mph set in Germany in 1981.

It took two years for sixteen-year-olds Vikki White, Bella Harrison, Chris Duncan and Ben Richardson to build *Volta*, in Fairhurst's garage, as part of their craft, design and technology course.

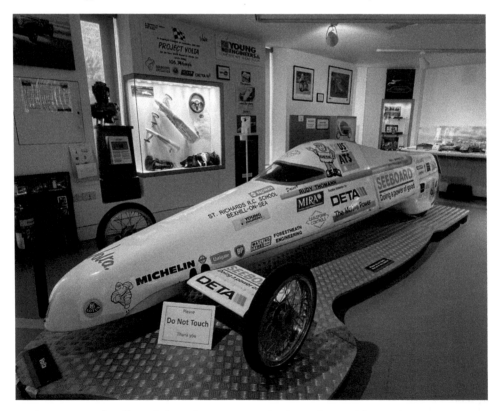

Students at St Richard's Catholic College set a new land speed record for an electronic car with their vehicle *Volta*. (Bexhill Museum)

W

Walpole, Horace

In 1771 the writer, art historian and antiquarian Horace Walpole bought a stained-glass window he admired from St Peter's Church in Bexhill Old Town, and installed it in the chapel at his home, the Gothic Revival Strawberry Hill House in Twickenham, south-west London.

Walpole (1717–97) believed that it featured portraits of Henry III and his queen, Eleanor of Provence. The window, which was returned to St Peter's in 1921 and is now in the north aisle, is actually a composite created from fragments of fourteenth- and fifteenth-century glass, featuring a number of saints, including St Laurence and St Andrew. It is thought unlikely that Henry and Eleanor are portrayed.

Webb, John

When the 7th Earl Sackville set out to develop Bexhill as a seaside resort in the 1880s, he began by commissioning the South London builder John Webb to build a sea wall

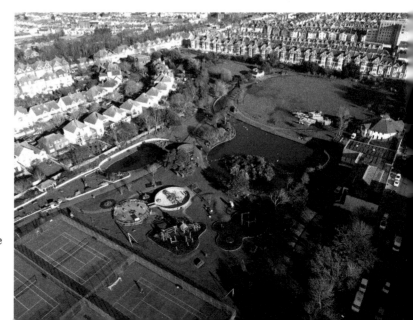

Right and overleaf: Egerton Park, created by John Webb in 1883. (Dr-Mx under Creative Commons)

and esplanade from Galley Hill in the east to Sea Road, thereby stabilising what was an area of coastal marsh, and making it suitable for development.

In part payment, the Earl split the available land with Webb (1840–1922), who went on to construct much of the new town for him. He gave Webb the land south of the railway, from Sea Road west to the Polegrove, where the shops and services would be located, and kept the east, where grand houses and fine hotels were built.

Webb laid out most of the roads in the town centre and in 1883 created Egerton Park, turning a stretch of swamp into elegant public gardens complete with water features, lush lawns, tennis courts and a bandstand.

Wilson, Angus

Novelist Angus Wilson, author of the *Dance to the Music of Time* series, was born and brought up in Bexhill.

Wilson (1913–91) was Professor of English Literature at the University of East Anglia from 1966 to 1978 and helped found its then groundbreaking creative writing course, which has since produced many famous novelists, including Kazuo Ishiguro, winner of the Nobel Prize for Literature, and Booker-prize winner Ian McEwen.

The twelve-volume *Dance to the Music of Time* series is an often comic and satirical study of mid-twentieth-century cultural, political and military life. It became a four-part Channel 4 series in 1997.

X-Men

A Bexhill typewriter repairer has played a small but vital role in the phenomenally successful X-Men film series, about the exploits of a team of superheroes.

The films, based on characters first featured in Marvel comics, have grossed $6 billion, and are the eighth most popular franchise of all time. The producers called upon the expertise of George Blackman and his son, Neil, who run George Blackman Business Equipment in Sackville Road, for help with a vital prop used in the fourth film, *X-Men: First Class*, in 2010.

The film-makers needed a rare 1930s typewriter restored. George Blackman told the *Bexhill Observer*:

> They wanted to know if we could restore a pre-war Continental typewriter to full working order and have it ready for filming in a matter of days. It was also essential that it should have German characters and keys, such as Umschalter for the shift mechanism and Rucktaste for the backspace.

George Blackman Business Equipment played a key supporting role in an *X-Men* movie.

Young, Henry

The way the main coastal railway line cut through the area caused real problems as Bexhill developed as a resort. As buildings sprang up to north and south of the station it became clear that the line was cutting the town in half, threatening its development.

Just a narrow cattle arch had been built beneath the elevated line, which was adequate for the original purpose of linking farms to the north of the rails with their fields to the south, but became a terrible bottleneck when Sackville Road was laid out at this point.

The problem was solved by Henry Young of Cooden Mount. The arch was replaced in 1892 with a cast-iron bridge over the road, built at Young's Pimlico foundry. It survived until 1978, when the present bridge replaced it.

The original narrow cattle arch had to be replaced when Sackville Road was developed.

Z

ZIM

Michael Cowpland, founder of high-tech companies ZIM, Mitel, and Corel, was brought up in Bexhill and attended Bexhill College until he was eighteen.

ZIM invests in a wide range of biomedical research companies, and in the field of emerging technologies. Its interests include research and development of novel cancer therapies and developing advanced materials to be used in 3D printing.

Cowpland, who was born in 1943, moved to Canada, where he founded Corel, originally called Cowpland Research Laboratory. At Corel he pioneered desktop publishing software for early home computers, success coming in 1989 with the launch of the graphics software CorelDRAW.

In 1996, Cowpland's Word Perfect challenged Microsoft's Word for dominance of the document-creating software market, but lost out when Microsoft was able to get Word loaded onto the majority of new computers, together with Windows.

In his book *Random Excess: The Wild Ride of Michael Cowpland and Corel*, Ross Laver describes him as 'an engineer whose greatest talent is in marketing'.

Cowpland also co-founded Mitel, which makes telephone systems for businesses. He lives with his second wife, Marlen, in an £8 million house in Rockcliffe Park, Ontario, Canada.

Bibliography

In writing this book, I have read or consulted the following books, publications and websites:

Anonymous *Accessing Virtual Egypt, Bexhill Museum* (ucl.ac.uk)
Anonymous *Agatha Christie* (agathachristie.com)
Anonymous *Agatha Christie Wiki* (agathachristie.fandom.com)
Anonymous *Amsterdam* (historymap.info/Amsterdam)
Anonymous *Amsterdam* (shipwreckmuseum.co.uk/amsterdam)
Anonymous *Best Years of Your Life* (bexhillmac.co.uk)
Anonymous *Desmond Llewelyn* (theguardian.com/film/1999/dec/20/news.obituaries)
Anonymous *Driving error that killed Bond star Q* (theargus.co.uk)
Anonymous *Street Names* (bexhill-osm.org.uk/streetnames)
Anonymous *The Haraga Tomb Group* (metmuseum.org)
Baird, Malcolm *John Logie Baird in Bexhill* (discoverbexhill.com)
Boyd, William *Why I love Keane* (theguardian.com/music/2012/jun/14/william-boyd-why-love-keane)
Christie, Agatha, *An Autobiography* (London: Harper Collins, 2001)
Christie, Agatha, *The A. B. C. Murders* (London: Harper Collins, 2007)
Clark, David; Roberts, Andy, *Grindell 'Death Ray' Matthews* (rexresearch.com)
Di Fiosa, Jimahl, *A Coin for the Ferryman: The Death and Life of Alex Sanders* (USA: Logios, 2010)
Dunbar, Roger A., *Elva Cars* (elva.com)
Ellis, Clive, *Fabulous Fanny Cradock* (Cheltenham: History Press, 2007)
Hilts, Carly, *The Shipwreck Museum, Hastings, and the Wreck of the Amsterdam* (the-past.com)
Izzard, Eddie, *Believe Me* (London: Michael Joseph, 2017)
Kaplan, Jenny, *Explorers & Contenders: Kate Marsden* (encyclopedia-womannica.simplecast.com)
Kempshall, Chris, *Cooden Camp* (eastsussexww1.org.uk)
Laver, Rod, *Random Excess: the Wild Ride of Michael Cowpland and Corel* (London: Viking, 1998)
Lycett, Sally Ann, *Six Minutes to Midnight and Me* (dlwp.com)
Perry, Jimmy; Croft, David, *Dad's Army* (London: Sphere, 1976)
Porter, Julian, *The Story of Bexhill's Pre-war Nazi Girls' School* (bexhillmuseum.org.uk)
Rice-Oxley, Tim; Hughes, Richard; Chaplin, Tom; Quin, Jesse, *The Sovereign Light Cafe* (London: Universal Music Publishing, 2012)

Rice, Katy, *Fossil hunter finds the world's first known dinosaur brain in Bexhill* (theargus.co.uk/news)

Richardson, Diana, *John Logie Baird by his daughter* (helensburgh-heritage.co.uk)

Schenk, Peter, *Operation Sealion: The Invasion of England 1940* (London: Greenhill, 2019)

Spray, Arthur, *The Mysterious Cobbler* (London: Francis Mott, 1935)

Starr, Alan, *Literary Sussex* (Stroud: Amberley, 2021)

Upton, Julia, *Joyce Lankester Brisley* (londonpsychotherapy.blog)

Withers, Charles W. J.; Lorimer, Hayden, *Geographers: Biobibliographical Studies, Volume 27* (London: Geographers; 2015)

Acknowledgements

The author and publishers would like to thank the following people/organisations for permission to use copyright material in this book. Special thanks must go to Bexhill Museum, for permission to photograph exhibits.

I have also used a number of photos by Dr-Mx (Alexis Markwick), who says of his work: 'Most of my photos are used over at https://bexhill-osm.org.uk - a community project using OpenStreetMap. It aims to celebrate pride, independence and wealth of history in and around the English town of Bexhill-on-Sea.' I am grateful to Alexis for making his work available under Creative Commons.

Every attempt has been made to seek permission for copyright material used in this book. However, if we have inadvertently used copyright material without permission/acknowledgement we apologise and we will make the necessary correction at the first opportunity.